Oct. 3, 1983
Doris Cashmore

$7.95

PRINCES
AND
ARTISTS

HUGH TREVOR-ROPER

PRINCES
AND
ARTISTS

*Patronage and ideology
at four Habsburg courts
1517–1633*

with 123 illustrations

Thames and Hudson · London

Picture Research: Georgina Bruckner

Printed and bound in Great Britain by Jarrold and Sons Ltd, Norwich

CONTENTS

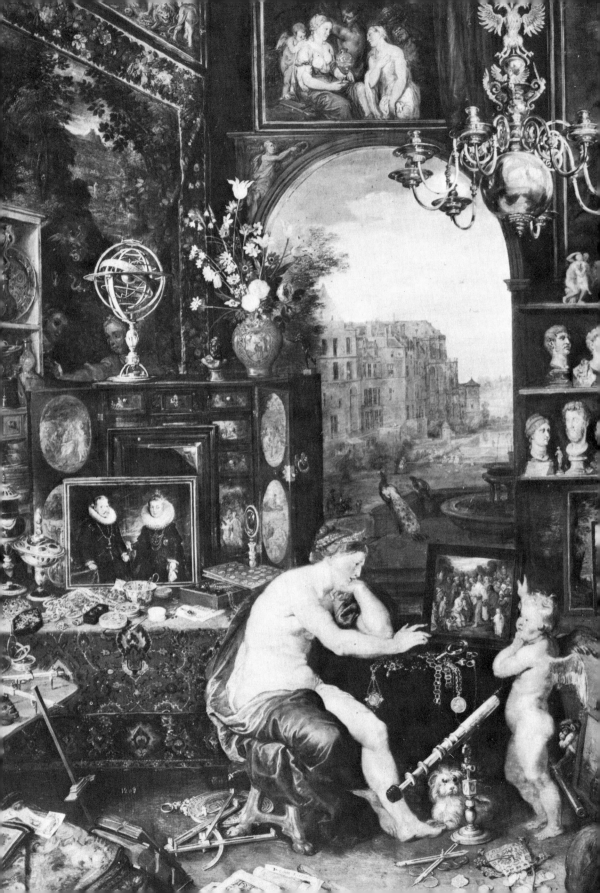

Preface

THESE LECTURES WERE DELIVERED at the State University of New York, College at Purchase, New York, in October 1974, being the first of the annual Yaseen Lectures endowed by Mr and Mrs Leonard Yaseen, to whom I am happy to present them in this more permanent form, as an expression of gratitude for their generosity and hospitality.

The Yaseen Lectures, delivered at the Roy R. Neuberger Museum at Purchase, are intended to illustrate some aspect of the visual arts. I am not an art historian, and would not venture alone, with my light equipment, into that fascinating but perilous labyrinth of bristling poleaxes and flickering stilettos. I am a plain historian; but I happen to believe that the art, like the literature, of any country, or century, as it is an expression of its ideas, is an inseparable part of its history, illuminating it and being illuminated by it. History which ignores art or literature is jejune history, just as a society without art or literature is a jejune society, and, conversely, art and literature which are studied in detachment from history are only half understood. Of course great art, and great literature, always transcend the historical context which has formed them: that is what constitutes their greatness. But if it is by their transcendence that they survive the historical circumstances which engendered them, equally it is by their historical circumstances that they are not only admired but understood. In short, I believe, with a great living historian, M. Fernand Braudel, that art and literature are 'les vrais témoins de toute histoire valable', the true witness of all history that is worth preserving: they are the spiritual deposit which reminds us that we are the heirs of a living civilisation.

For this reason I would like my fellow-historians to include art and literature in the evidence of history: indeed, to see them as part of the substance of history; and I would like art historians and men of letters to see history as a contribution – though of course no more than a contribution – towards the understanding of art and literature. Certainly I myself have found the study of history enriched and deepened by the study of its art, and I note that the great art historians, or at least those who have meant most to me – Jacob Burckhardt, Carl Justi, Emile Mâle – have been historians in the widest sense: historians not of art only, but of men and ideas.

Of course this is not equally true of all periods. There are periods without art, as there are periods without ideas, and there are periods when art is, or seems, detached from the ruling ideas of the time. But even then, the problem remains: why this apparent absence, why this detachment? This is a general,

Jan Brueghel (1568–1625), *The Allegory of Sight* (detail). One of a series of allegories of the five senses painted by Brueghel in 1616–17. The room may be based on the studio of Rubens in Antwerp. It contains unfinished paintings by Rubens, a bust of Seneca, and a portrait of 'the Archdukes', the rulers of the Netherlands and patrons of Rubens and Brueghel.

7

philosophical problem, a problem in the philosophy of history, which for the moment we may leave in suspense. Meanwhile, I shall descend to particulars, to the subject which I have chosen. I have chosen a period of European history when great art and powerful ideas were intimately connected: a period of ideological tension and excitement which, for several reasons, was directly expressed in art by some of the greatest European artists, both directly, through personal conviction, and indirectly, through patronage. It is the period, in art history, from the high Renaissance to the baroque; in ideology, from the Reformation to the Counter-Reformation; in politics, from the high hopes of humanism and the revived medieval Empire of Charles V to the last internal clash of militant Christianity and the brutal *Machtpolitik* of the Thirty Years War.

Within this large subject, as a convenient illustration of it, I have chosen to write of the art-patronage of certain princely courts. This is not because I suppose that art springs from the court. Quite clearly it does not. European art sprang, in the Middle Ages, from the Church, the source of ideas, and from the cities, the source of wealth. The free commercial cities of Italy, Flanders, the Rhineland, south Germany – these were the economic motors of medieval Europe, and they also produced the great artists. In general, we can say, the great art schools are to be found in the same cities which produced the great banks: Siena, Florence, Venice, Ghent, Bruges, Antwerp, Augsburg, Nuremberg. But at the time of the Renaissance, the princely courts took over both the cities and the Church. Therewith they took over both the production and the direction of art, and made it serve their propaganda and their prestige. Art was pressed into service for evanescent outward shows, in the public spectacles, the triumphal processions, the 'Joyous Entries' of princes; it was made permanent in great princely collections, the continuation, in a new age and a new form, of the medieval princely treasure-houses. *Kunstkammer* of dynastic gems and emblems became, in a more aesthetic age, galleries of pictures and statues. As the fashion took root, and created new industries to sustain it, so it spread outwards and downwards: outwards from court to court, through networks of marriage, diplomacy, commerce, from Italy and Burgundy to the hitherto unsophisticated courts of Spain and England, Denmark and Saxony, Holstein and Pomerania; downwards from royal courts to noble houses, from Charles V to his ministers, secretaries, financiers; from Philip II to the Spanish grandees – war-lords in one generation, greedy connoisseurs of the arts in the next; from Rudolf II to the Bohemian nobility; from Charles I of England to the noble patrons of van Dyck and Lely.

Among these competing courts of Europe, I have chosen the Habsburg courts partly because the rulers of the house of Habsburg showed the most continuous interest in the arts, partly because the changing pattern of patronage in their several and successive courts illustrates vividly, as I believe, the distinct phases of the great ideological crisis of the time. I shall show the

Emperor Charles V throughout Europe, king Philip II of Spain in Madrid, the Emperor Rudolf II in Prague, and the archduke Albert in Brussels, as personal patrons, each with a distinct taste in art, but each also, by the pattern of his patronage, reflecting a different stage in the changing European *Weltanschauung*. All these rulers were Roman Catholic in their religion; and their Catholicism made them heirs to the artistic traditions of their Church. But the Catholicism of each was different. Charles V looked back to the universal Church which sanctioned his universal empire and dreamed, spasmodically but seriously, of a reform that would prolong its unity. Philip II, resolute in the defence of a threatened orthodoxy, and confident in the secular power and undivided, crusading, spirit of Spain, sought to reimpose, unconditionally, a system which, as even its defenders knew, could only be preserved by retreat and change. Rudolf II, uncommitted by the new programme of the Church, and imprisoned by the realities of divided dominions and an uncertain power, sought to evade the issue and preserve the secular traditions of the past, at whatever cost in orthodoxy. 'The Arch-dukes' in Brussels found themselves politically weak but entrusted with the ideological propaganda of the Catholic Counter-Reformation. The artists whom these rulers patronised reflect these changing attitudes; and a consideration of those artists, and that patronage, in their historical context, may, I hope, illustrate a crisis of society and a chapter in the history of ideas.

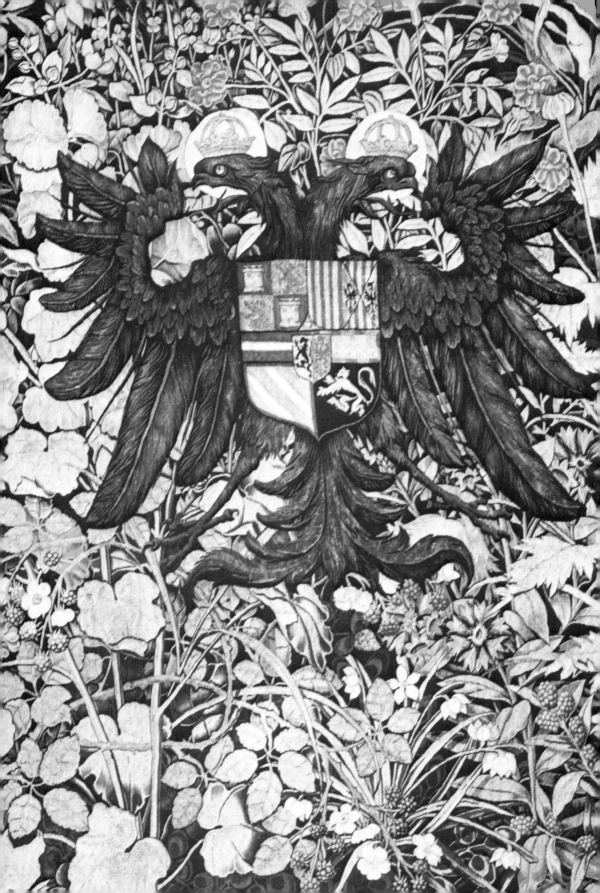

CHAPTER I

Charles V and the failure of humanism

IN ANY DISCUSSION OF THE ART-PATRONAGE of the house of Habsburg in the century of the Renaissance, it is tempting to begin with that fascinating ruler, the Emperor Maximilian I. He was the visionary of the family, the founder of its myth. We see him as *der letzte Ritter*, the last paladin of the chivalric Middle Ages, the universal man, or perhaps the Don Quixote of northern Europe, and he engages our interest with his boundless imperial dreams, his chimæra of a crusade against the Turks, his perpetual insolvency, his inconsequent Viennese charm, his personal creative interest in all the arts. But in spite of his vast projects, Maximilian remained essentially an Austrian prince, a prince of his dynasty, only indirectly in touch with Renaissance ideas. Though he married the heiress of Burgundy, he regarded that inheritance as belonging to his son, and himself as a trustee only: he could not feel himself the natural heir to the achievements of Flanders – far less appropriate to himself the inheritance of Italy or imagine the vast new opportunities of a remote country beyond the Pyrenees. All these legacies and opportunities would fall, thanks to his elaborate dynastic matrimonial policy, to his grandson, Charles V. Born a native Netherlander, Charles V (as we always call him) would be count of Flanders and duke of Burgundy at five, duke of Milan, king of Naples and king of Spain at sixteen, Emperor at nineteen, master of Italy at thirty, conqueror of Tunis at thirty-five. Even Maximilian, in his most visionary moods, could hardly have envisaged such glory for his house.

How can anyone summarise the rule, the personality of Charles V? He eludes his historians because at once he is so obvious and so indefinable, so greedy in his acquisitions and yet so conservative in his aims. He ruled over more of Europe than any man until Napoleon and yet he acquired that empire almost accidentally, by the most conventional methods. He loved war and yet fought it always in postures of defence. Finally, having fought for forty years to build up and conserve that vast empire, he astonished all Europe by quietly abdicating and retiring to a remote monastery in rural Spain.

Above all, when we think of Charles V, we must be impressed by his amazing energy. This slow-speaking, formal man, with his protruding Habsburg jaw, his deep love for tradition and his own country, his pleasure in protracted social occasions – those hunting parties and feasts which lasted for days on end – his gradual absorption into the glutinous texture and dilatory tempo of Spanish life, and ultimately, his total immobility through

This detail of a tapestry made in Brussels during the second half of the sixteenth century is from one of a series of eight, each with the double-headed eagle of the Holy Roman Empire and the arms of the Emperor Charles V against a background of foliage and flowers.

gout, seems, throughout his reign, to have been in continual motion. He never had a fixed capital: his capital was wherever he happened to be. He carried his migratory court with him to Brussels, Valladolid, Granada, Frankfurt, Augsburg, Milan, Naples; and wherever we find him, he is not only governing his vast empire, either directly through secretaries, or indirectly through viceroys: he is also continuously at war. The mere catalogue of his incessant travel is exhausting. There is something oppressive about that famous speech which he made in Brussels in 1555, at the ceremony of his abdication. He was only fiftyfive years old, but already he was physically exhausted by his efforts. A prematurely aged man, unable to stand unaided, he leaned on the shoulder of the young prince of Orange – the same prince who would be the mortal enemy of his son – and recited the long list of the journeys which had ultimately worn him down: 'in the course of my expeditions, sometimes to make war, sometimes to make peace, I have travelled nine times into High Germany, six times into Spain, seven times into Italy, four times into France, twice into England, and twice into Africa, accomplishing in all forty long journeys, without counting visits of less importance to my various states. I have crossed the Mediterranean eight times and the Spanish Sea twice. . . .'

How, we may ask, could such a man, in such a time, burdened with such tasks, a man whose whole life seemed preoccupied with acquisition and defence – acquisition of this huge empire in Europe, and another in America

(for it was for him that Cortez conquered Mexico and Pizarro Peru), defence of it against the old enemy, the French – the magnificent François I – and the new enemy, the Turks – the invincible Suleiman the Magnificent – and, most difficult of all, against inner heresy – against the all-pervasive Reformation which was dividing one country after another, opening rift within rift, depth below depth – how could such a man, whose economic resources were so difficult to mobilise, whose every gesture of defence had to be preceded by desperate financial negotiations with the cortes of Castile, or the cities of the Netherlands, or the great capitalists of Augsburg – how could he find the time to be a discriminating, enthusiastic patron of the arts?

The easy answer, of course, is to evade the problem. The most famous historian of Charles V, William Robertson, the friend of Hume and Gibbon, says nothing whatever about his taste in art. But then Robertson, who was a Presbyterian clergyman and Moderator of the General Assembly of the Kirk, though a great 'philosophical historian', was perhaps not very sensitive in aesthetic matters. A century later, the American historian W. H. Prescott, in his long, two-volume history of Charles V, approaches the subject, but only to dismiss it lightly, even condescendingly. The Emperor, he wrote, was 'a true lover of art and, for a crowned head, no contemptible connoisseur'. What entitled Prescott (who was almost totally blind) to assume that crowned heads were, in general, lacking in fine taste, is not clear. Perhaps the assumption was fair in his time. But to apply it to the sixteenth century is not only unjust:

Albert Dürer (1471–1528), the triumphal car of the Emperor Maximilian I, 1518 (preliminary drawing for the woodcut). Above the seated Emperor are allegorical figures representing Justice, Temperance, Fortitude and Prudence, and among the other attributes referred to in the picture are Reason, Nobility and Power. The feathers behind the figure at the extreme left indicate the Emperor's claims of sovereignty or alliance: Italy, Hungary, Switzerland, Germany, France, Venice.

13

it is also unhistorical; for it fails to recognise the central function which art and art-patronage then performed in the necessary symbolism, the as yet undivided, unspecialised *Weltanschauung* of a ruling house.

A true appreciation of Charles V's love of art was brought about, especially, by two men who, unlike Robertson and Prescott, actually visited Spain and saw for themselves the long-neglected deposit of imperial times. Richard Ford, a gentleman of Devonshire, was himself an artist and a man of taste; in a series of tours on horseback between 1830 and 1834, he explored Spain as no foreigner, and perhaps no Spaniard, had ever done before; and the *Handbook for Travellers in Spain* which he published in 1845 is one of the world's great guide-books, still indispensable to the historically minded traveller, irresistible to the historically minded reader. On every page of it, Ford reveals, together with his political prejudices, his artistic sensitivity. He disliked the Habsburgs with a robust English disdain for popish super-stition and political despotism; but at the same time he recognised the genuine taste even of 'the chilly Fleming' Charles V and the 'dull, cold bigot' Philip II. An even greater service was performed by Ford's young friend, the Scotsman Sir William Stirling Maxwell. In 1843, at the age of twenty-five, Stirling (as he then was) went to Spain and there discovered, and re-vealed to the world, a whole range of art which, in his time, had been for-gotten. Stirling was in fact the rediscoverer of Spanish art. With marvellous judgment, he built up for himself a huge collection whose superfluity has since supplied the museums of Britain and America. Because of his own fine taste, Stirling could see what previous historians had missed; and in his classic work, the *Cloister Life of Charles V*, which he published in 1852 and dedicated to Ford, he emphasised that the Emperor too was a genuine aesthete: a man whose name 'is connected not only with the wars and politics but also with the peaceful arts of his time: it is linked with the graver of Vico, the chisel of Leoni, the pencil of Titian and the lyre of Ariosto; and as a lover and patron of art his fame stood as high at Venice and Nuremberg as at Antwerp and Toledo.'

How could it be otherwise in the grandson of Maximilian, brought up in Flanders, Burgundian Flanders, in the full luxuriance, the last gothic extravagance of the northern Renaissance? All the family of Charles V, men and women alike, were lovers of art, and art surrounded him from his earliest days. His guardian, as a child – for his father was dead and his mother mad in Spain and his Burgundian relations would not allow him to be carried off and austrianised by his grandfather in Innsbruck or Vienna – was his aunt, the early widowed Margaret of Austria. She would build, in Burgundy, for herself and her dead husband, the breathtaking memorial church of Brou at Bourg-en-Bresse, and her court at Malines, whence she governed the Netherlands for her father and her nephew, was a humanist centre, the capital of art and letters in the north. With him there, as a child, was his younger sister Mary, Queen of Hungary, another early widow, who would afterwards,

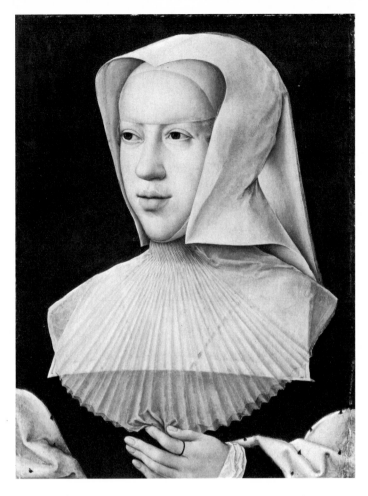

in her turn, rule the Netherlands for him. Mary would equally become a great patron, equally a lover of Flemish flamboyance, filling with books and pictures the enchanted castles which were built for her by her architect and sculptor Jacques Dubroeucq at Binche and Mariemont. Charles himself always had Flemish tastes. He loved Flemish architecture and Flemish music – the elaborate polyphony of Guillaume Dufay and Josquin de Prés. He was Flemish too in his pleasures: hunting, eating, drinking. But as he moved the seat of his empire to the south, first from Flanders to Spain, then from Spain to Italy, so this Flemish luxuriance was tempered by an Italian regularity. Aesthetically, the reign of Charles V – those forty years from 1516 to 1556 – is a period in which northern and Italian influences were fused: Dürer drinks from Venetian, Titian from northern fountains; the Emperor's great minister Granvelle builds an Italian palace at Brussels; and in Spain the mingling of gothic and Italian styles produces that unique phenomenon, the composite style associated largely with the reign of Charles V, the 'plateresque'.

Margaret of Austria (1480–1530); a portrait by Bernaert van Orley.

15

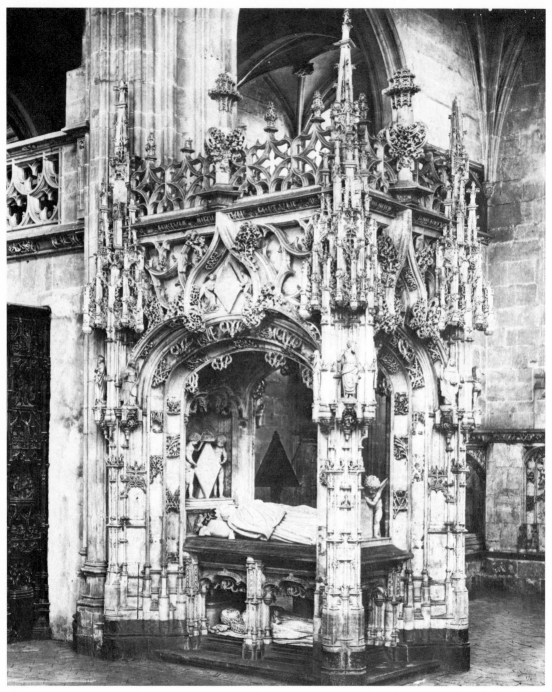

The tomb of Margaret of Austria in the church of Brou, which she built as a memorial for herself and her husband, Philibert of Savoy.

The legend of Notre Dame de Sablon; detail of a tapestry made in Brussels, 1518, after designs by Orley. The two figures carrying the statue of the Virgin and Child are Charles V (wearing the crown) and his brother Ferdinand.

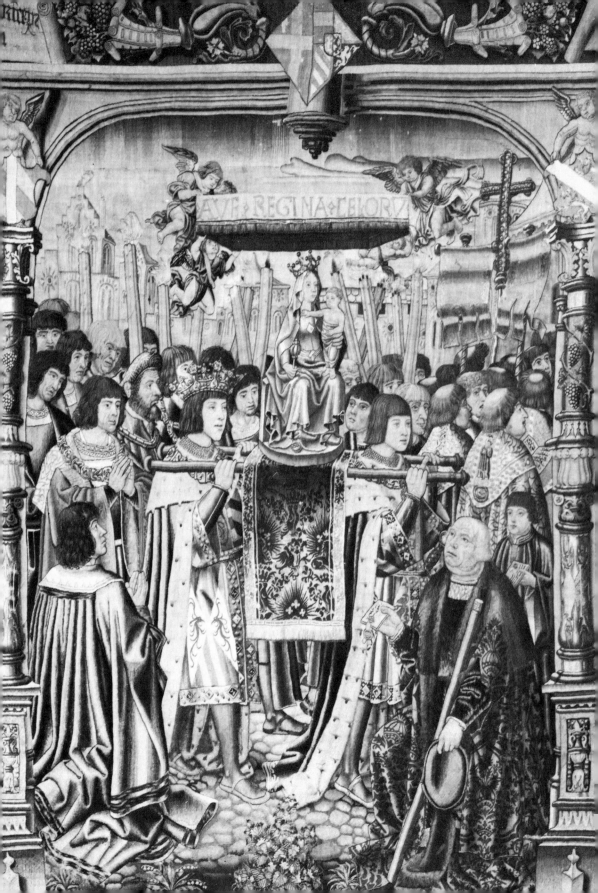

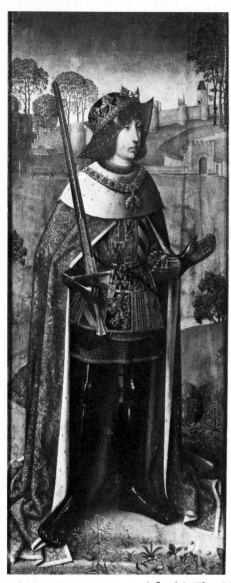

Charles V's parents depicted in a fifteenth-century Flemish triptych. Left, Philip the Fair (1479–1506), son of Maximilian I, and (right) Juana of Spain (1479–1555), queen of Castile.

After his Flemish upbringing, the young Charles V went first to Spain to collect his Spanish crowns and then to Germany to bid, successfully, for the succession to his grandfather as Holy Roman Emperor. Then he returned to Flanders and in 1520 made his 'Joyous Entry' into Antwerp. The ceremony of a 'Joyous Entry', or *Blijde Inkomst*, was a great feature of the Renaissance courts, and nowhere had its ceremonial magnificence been more richly elaborated than in the duchy of Burgundy where it had acquired a political significance, symbolising a form of compact between the prince and the town. It was an occasion for processions and feasts, triumphal arches and *feux de joie*; and painters and poets would be there, eager with their work to win, or to justify, their court appointments and laurel crowns.

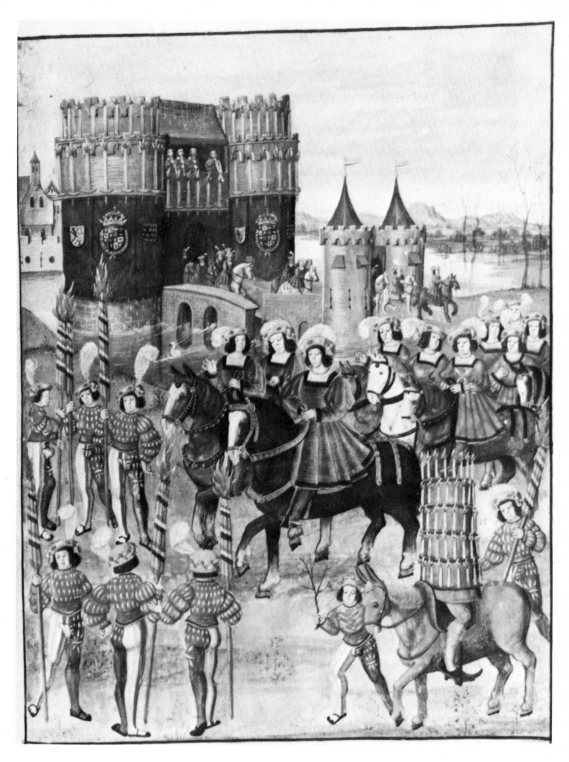

A 'Joyous Entry' of the young Charles into Bruges; from a Flemish miniature, 1515.

Among those who came to meet the Emperor on this occasion was the greatest of south German artists, Albert Dürer. Recently, the late Emperor Maximilian had discovered Dürer and had made him his court‑painter. Dürer had illustrated Maximilian's prayer‑book, designed his Triumphal Arches, portrayed his ancestors, drawn up his dynastic propaganda; and one of the last of the many portraits of that iconographically minded Emperor, drawn from the life at the Diet of Augsburg and published after his death, had been by Dürer. Now, after Maximilian's death and Charles V's election, Dürer came to the Netherlands to secure the continuation of his stipend as court‑painter. The first visible effect of the appointment was Dürer's design for the silver medal of Charles V in 1521. But perhaps the greater experi‑ ence of his Netherlands visit, for Dürer, was his meeting with the prince of humanists, the friend and counsellor of the Emperor, Erasmus.

In 1520 Erasmus was the hero of liberal Europe. By his 'Philosophy of Christ', expressed in his New Testament and his *Enchiridion*, he had con‑ quered the élite of Christendom. The Emperor and his court revered him, and wherever that migratory court went, the message of Erasmus was carried with it. Already it had been carried into Spain, with explosive effect: 'Erasmianism', transmuted in that dark, multi‑racial crucible into a new form of mysticism, would dominate the intellectual and religious life of the peninsula for a generation and more. All over Europe, from Poland to Gibraltar, from Scotland to Sicily, cultivated and liberal men, courtiers and clergy, merchants, officials and scholars, would read the work of Erasmus, study his thoughts, venerate his name; and even when his works had been banned and his name could no longer be mentioned, his teaching would still form the minds of a new generation.

Like everyone else, Dürer too was carried away by Erasmus. He drew him twice, and afterwards published the drawing: the quiet scholar with his fur‑lined gown and half‑shut eyes, facing his books and a pot of flowers, who was nevertheless, at that time, the hope and inspiration of Europe. In 1521, when the Emperor went to meet Luther at the Diet of Worms, it seemed as if agreement was in sight. The European establishment, represented by the young Emperor, was about to accept the new message of humanist reform represented by Luther, not yet soured and frightened by revolution, and by Erasmus, not yet separated from him by the remorseless course of events.

Silver medal designed for Charles V by Dürer in 1521 (obverse and reverse).

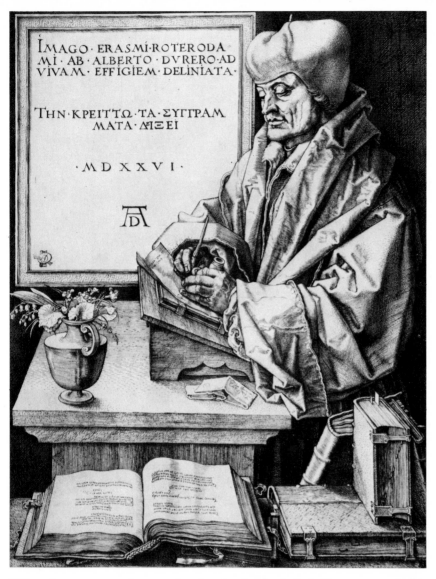

Within the engraving:

IMAGO·ERASMI·ROTERODA
MI·AB·ALBERTO·DVRERO·AD
VIVAM·EFFIGIEM·DELINIATA·

ΤΗΝ·ΚΡΕΙΤΤΩ·ΤΑ·ΣΥΓΓΡΑΜ
ΜΑΤΑ·ΔΕΙΞΕΙ

·MDXXVI·

When it was reported, wrongly, that Luther had died, Dürer wrote in his journal, 'O Erasmus of Rotterdam, where will you be? Hear, you knight of Christ, ride forth beside the Lord Christ, protect the truth, obtain the martyr's crown.' 'Knight of Christ' is a reference to Erasmus' most famous devotional work, *Enchiridion Militis Christiani*, 'the handbook of the Christian knight'. This little book was probably the inspiration of Dürer's famous engraving known to us as 'the Knight, Death and the Devil', of which Dürer was now distributing copies in the Netherlands. Such was the exaltation of spirit, the confidence of liberal men, the belief in the possibility of reform and enlightenment at the beginning of the Emperor's reign. It is essential to remember it when we come to the end.

Desiderius Erasmus of Rotterdam (1465–1536); the engraved portrait by Dürer, 1526.

21

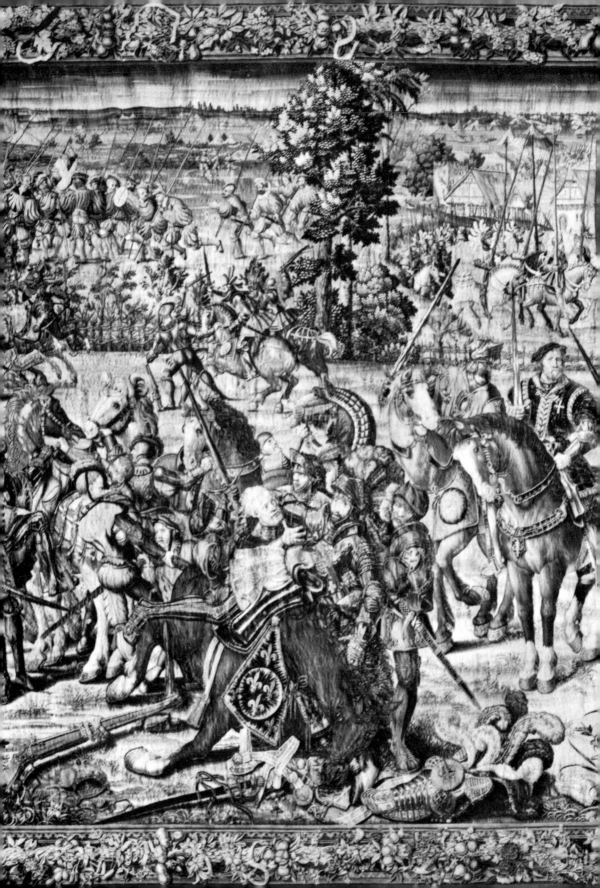

The power to reform the world depends, in politics, on the power to rule the world. Christianity did not prevail in the Roman Empire till the imperial power had been firmly re-established, and Lutheranism in Germany would have been a mere dream but for the German princes. For the next ten years the Emperor sought to establish his rule, to render real the vast power that was now nominally his. To do this, he had to exert himself in all directions. He must crush rebellion in Spain, resist France in the west, the Turks in the east, control Lutheran heresy in Germany, restrain the pope in Rome. After ten years of unwearying efforts, all this had been done. The king of France had been defeated at Pavia; the pope, after the sack of Rome, had resolved to be good; French power had been driven out of Italy; the Medici had been restored in Florence; the Emperor had been crowned by the pope at Bologna and had seen his younger brother Ferdinand elected and crowned as king of Hungary, king of Bohemia, and king of the Romans – that is, heir to the Empire – in Germany. The ancient Imperial power, the inheritance of the Roman Empire, of Charlemagne, of Frederick II, the vision which had floated, like an unattainable phantom, before the eyes of Maximilian, seemed suddenly to have become real. At Bologna the Emperor had seen his portrait hung in the streets with those of Augustus and Trajan: Augustus, the founder of the Empire, the patron of poetry and the arts; Trajan who also, like Charles V, came to Italy from Spain.

In 1530 Charles V was crowned Emperor in Bologna by pope Clement VII. In a detail of I. N. Hogenberg's engraving of the coronation procession, the Imperial banner is on the left, the papal banner, with the Medici emblems, on the right.

(Opposite) The defeat of the French at Pavia in 1525; detail of a sixteenth-century tapestry.

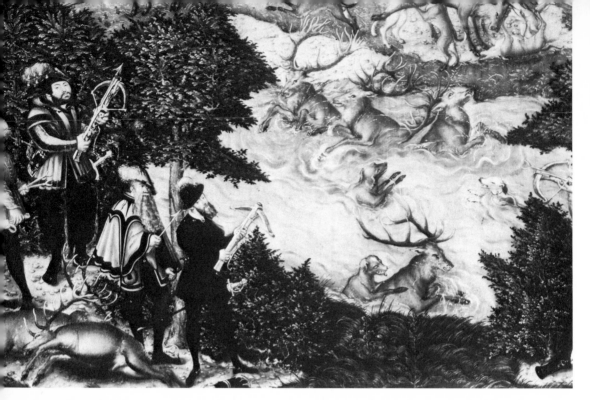

Detail from a hunting scene by Lucas Cranach the Elder (1472–1553). The foreground figure in dark clothes holding a crossbow is Charles V.

What ambitions of ancient grandeur beckoned Charles V at the time of his coronation! That was the time, as it seemed, of humanist triumph. The humanists who surrounded him, his officials, his courtiers, his propagandists, all dreamed of an imperial revival. All looked back to his great Roman or medieval precursors. Some, like his Piedmontese chancellor, Mercurino Gattinara, imagined a universal monarchy, and pressed for further conquest, further annexation. The Emperor himself was more conservative. He repudiated the idea of conquest: conquerors, he declared, were tyrants; he aimed only to be the accepted president of the *universitas Christiana*, the federation of Europe.

It was in 1531 that the Emperor saw his brother crowned king of the Romans in Aachen, the capital of Charlemagne. Then he returned to Italy and in November 1532 he stopped for a time at Mantua, at the court of his client prince, the duke Federigo Gonzaga. There he discovered two of the greatest artists of high Renaissance Italy who, in different media, were to celebrate him. The first was the poet Ludovico Ariosto, whom he met personally. Ariosto had come from Ferrara to present to the Emperor in person his famous poem *Orlando Furioso*, to which he had specially added new stanzas for this occasion. Like Vergil before him, he made an ancient prophetess foretell the glories of the present, when the whole world was to come under the rule of 'the wisest and the justest emperor that has been, or ever shall be, since Augustus': an emperor by whom Astraea, the goddess of Justice, will be brought back to earth, restoring the golden age which had been ended by her flight.[1]

In Ariosto, Charles V discovered Italian Renaissance poetry, poetry which had now been converted into propaganda for his universal rule. But at the same time he also discovered Italian art – as well he might, for the Gonzaga dukes of Mantua were among the greatest patrons of art in Italy. Their collection was the pride of the city and so would remain for another century, until its scandalous sale to Charles I of England. The numerous palaces of the Gonzaga had been decorated by Pisanello, Mantegna and Giulio Romano, and the reigning duke, a zealous collector, was one of the patrons of Correggio and of Titian. In 1530 he had introduced the Emperor to the work of Correggio, and commissioned Correggio to paint an allegorical work for him.[2] Now he introduced him to the work of Titian. The painting which particularly caught the eye of the visiting Emperor was the full-length portrait of the duke which Titian had painted, five years before. In it the duke stands with his right hand on the collar of his dog.

Up to this moment, Charles V had had no personal court-painter. In his early years in the Netherlands, his portrait had been painted by various Flemish and German artists – the artists of his family. There are juvenile portraits by the Fleming Bernaert van Orley, the court-painter of Margaret of Austria; by the Austrian Bernhardin Strigel, the court-painter of Maximilian; and by the great Lucas Cranach. But Titian's portrait of the duke of

Titian being presented to Charles V in Bologna in 1531. The ink drawing is attributed to Titian himself.

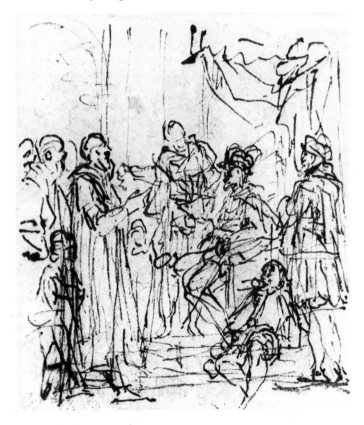

Mantua was a revelation. The Emperor was delighted with it and resolved to have himself (and his dog) painted by the same hand. He sought out Titian and, next year, contrived to meet him in Bologna. The result was Titian's first portrait of the Emperor: that famous portrait in which the Emperor stands, full-length, rather formal, even statuesque, with his hand on the neck of his wolfhound. It has been described as a Burgundian monumental portrait, northern, not Italian, in style; as it well might be, for it is in fact clearly based on a portrait recently painted at Bologna by Jacob Seisenegger, the court-painter of the Emperor's brother, Ferdinand, the new king of the Romans. We can see it as Titian's *prueba*, his sample work offered, to show what he could do, to a potential patron.

As such it was certainly a great success. When he saw it, Charles V's mind was made up. He decided that from now on – with occasional exceptions of course, dictated by need or courtesy – there would be only one painter for him. As Alexander the Great would never allow himself to be painted by any artist but the greatest of Greek painters, Apelles, so (says Vasari) 'this invincible Emperor' would never thereafter allow himself to be painted by any hand but that of Titian. He appointed Titian his court-painter, describing him in the official diploma as *huius saeculi Apelles*, the Apelles of this age; he made him count palatine, knight of the golden spur; and he gave him the singular title of *eques Caesaris*, knight of Caesar. Such favour would not be bestowed upon any other painter till the next century. Then Rubens, coming like Titian from the service of the duke of Mantua to that of the Habsburgs, would be given the same title, *eques Caesaris*, and would be described, on his tomb in Antwerp, by the same phrase, *huius saeculi Apelles*.

However, if Charles V chose to recognise only Titian as his court-painter, that did not exclude other artists from spreading the Habsburg myth in other forms or by other media. Shortly after enlisting Titian as his court-painter, Charles V decided to strike a blow at the infidel. In the early years of his reign, the Turks had pushed forward their conquests in a terrifying manner. By land and sea, citadel after citadel had fallen to them. They had captured Belgrade and Rhodes; then they had conquered most of Hungary, killed the Emperor's brother-in-law, king Louis of Hungary, taken and sacked Budapest, installed a puppet king to dispute the claims of the next heir, the Emperor's brother Ferdinand, and threatened Vienna. Meanwhile, they had extended their protectorate along the whole coast of North Africa. They had also made an alliance – an infamous alliance, good Christians thought – with the Emperor's other enemies, the French. What more natural than that the Emperor, now at the height of his power and crowned by the pope as the secular champion of Christendom, should seek to fulfil that recurrent dream of his grandfather Maximilian and launch, at last, the great crusade against Islam? As king of Spain, also, he was heir to the crusading policy which, after centuries of struggle, had recovered the peninsula from the Moors and carried the Christian 'reconquest' over the sea, into North Africa.

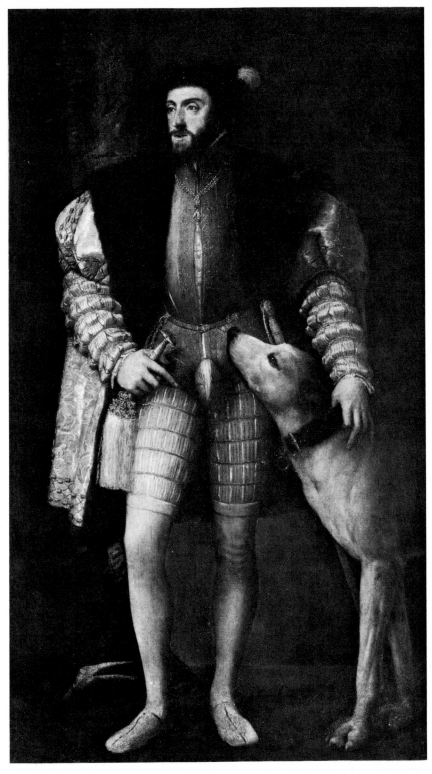

Titian's portrait of
Charles V, 1532.

In 1535 all the omens seemed favourable and the Emperor, having gathered a great multinational fleet at Barcelona, crossed the Mediterranean, landed in Africa, defeated the great corsair captain Khayreddin Barbarossa, stormed and captured Tunis. It was the first great victory of Christendom over Turkish power, and the reception of the Emperor, when he returned to Italy, was that of a conquering hero. From Messina to Rome it was a series of triumphal arches. The Emperor himself was exalted by victory. He was now the hero of Christendom, the new Scipio, the conqueror of Carthage. Indeed, like Scipio, in Roman style, he took the title 'Africanus', and special medals, designed by an Italian artist, were minted with his effigy as Carolus Imperator Augustus Africanus. On this Tunisian expedition the Emperor took with him a specially appointed court-painter, or perhaps we should say war-artist, Jan Cornelisz von Vermeyen.

Vermeyen was a Dutchman who had been court-painter to the Emperor's aunt, Margaret of Austria, the governor of the Netherlands. Now that she was dead, the Emperor had taken him over and used him, particularly, to paint battle-scenes: he painted the great victory of Pavia, over the French, in 1525, and the capture of Rome in 1526. He was the same age as the Emperor, who evidently enjoyed his company: we are told that the Emperor liked to present him to his courtiers, to show off his fine figure, 'which was graceful and slender', and his even finer beard, which was so long that he sometimes trod on it. Karel van Mander, the Dutchman who, at the end of the century, wrote the lives of the northern painters, as Vasari wrote those of his fellow-Italians, tells us that Vermeyen was honoured and loved by the Emperor, 'whom he accompanied like a fellow-emperor to various countries, and to Tunis and Barbary'. In Africa, Vermeyen made a series of sketches which he afterwards took back to the Netherlands and worked up into twelve large cartoons. These were the basis of twelve great tapestries which were woven in Brussels by the firm of Pannemaker, the most famous of Flemish tapestry-weavers, and afterwards sent to Madrid.

The memory of this great victory over Islam – brief though it was, for Tunis was soon lost again – would long remain part of the Habsburg myth. It would be repeated by the Emperor's son, don John of Austria, thirty-six years later. It would inspire his grandson, the Emperor Rudolf II. Nearly a hundred years after the event, Rubens, on a visit to Spain, would renew its memory for Philip IV in what Burckhardt calls 'a wonderfully spirited battle-sketch, with a magical radiation of movement and light from the centre';[3] and a hundred years later still, in the eighteenth century, the Emperor Charles VI would have another series of tapestries woven, in Brussels, from the same cartoons of Vermeyen to decorate his palace in Vienna.

And then there was sculpture. Here too Charles V showed a fine discrimination, and here too Titian played a part. Charles V's greatest sculptor was Leone Leoni of Arezzo, a kinsman and fellow-citizen of the famous, or

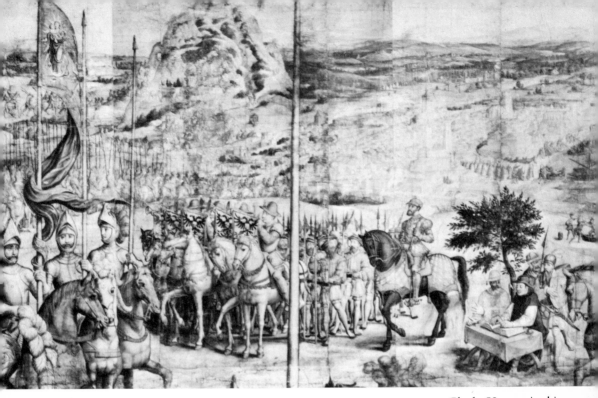

Charles V mustering his
army in Barcelona for
the battle of Tunis,
1535; detail of a
design for tapestry by
J. C. von Vermeyen
(1500–59).

Bronze medal
celebrating the
Emperor's victory at
Tunis.

infamous, poet and satirist, Pietro Aretino, whose pornographic *Postures* secretly delighted the curious and publicly shocked the virtuous of the time. Aretino in turn was the close friend and informal publicity agent of Titian. Thus Leoni soon found himself in Titian's circle in Venice. Another close friend of Titian was the Venetian humanist Pietro Bembo, the secretary of pope Leo X. Indeed, Titian, Aretino and Bembo were known in Venice as 'the triumvirate'. Bembo was Leoni's first patron: he took him to Rome and launched him in the city of the popes.

Leoni had begun his career as a goldsmith, a disciple of Michelangelo, an admirer of Leonardo. In Rome he was the hated rival of Benvenuto Cellini, and these two famous artists were indeed, in the wildness of their lives, fit for each other. When Cellini, in consequence of one of his many misde-meanours, was languishing in the papal prison, the Castel Sant' Angelo, Leoni contrived to capture his post as engraver of papal coins. But he soon lost that favour; after an unfortunate incident, in which he assaulted and permanently mutilated the pope's German jeweller, he was sentenced to lose his right hand. From such a fate, which would indeed have been fatal to his career and his art, he was saved in the end by powerful sponsors; but it was at some cost: Leoni's punishment was commuted and, like John Knox and some other famous men, he found himself serving time as a galley-slave. After a year in the galleys, he was released by the influence of Charles V's greatest sea-captain, the Genoese Andrea Doria, who found a use for his talents. Indeed, the grateful Leoni engraved a medal of Andrea Doria with himself, in galley-chains, on the other side. Thus emancipated, Leoni con-tinued his alternation of criminal violence and exquisite workmanship. One of his victims was one of his own workmen whom he tried to murder. One of his patrons was the Spanish governor of Milan, the marqués del Vasto, whose portrait Titian had painted. Vasto's successor decided to bring Leoni to the Emperor's notice, but it meant extracting him, without diplomatic friction, from other patronage. So the delicate system of private diplomacy was set buzzing. Aretino and Titian, the pornographer and the painter, were called in, and the matter was referred to the Emperor's greatest minister, the Burgundian Antoine Perrenot, bishop of Arras, afterwards better known as cardinal Granvelle. Granvelle, like his master, was a great patron of all the arts – indeed, one of the greatest private patrons of the whole century. He was also an old personal friend of Leoni; the two had been students together at the University of Padua; but while Leoni remained an incorrigible scapegrace, Granvelle had now become much more respectable. Such powerful pres-sure could hardly fail, and by 1546 Leoni had followed Titian into the Emperor's service. He and his son Pompeio Leoni were to be dominant figures in sixteenth-century sculpture and to exercise a profound influence on its development in Spain.

From 1546 onwards Leoni was the chosen sculptor, as Titian was the chosen painter, of the house of Habsburg. The friendship between the two

artists would be somewhat strained when Leoni attempted to murder Titian's much loved only son Orazio, who was staying with him in Milan on his way to collect his father's salary; but that unfortunate episode did not occur till 1559, after the Emperor's death: at present all went smoothly and the painter and the sculptor lived in fraternal amity and considerable splendour. Neither of them belonged to the court: how could they, when the court was perpetually on the move? Leoni lived in Milan, his adopted city: there alone, he explained, could he obtain the means to cast statues in bronze, and even kings had to send their orders to him. It was only with the greatest difficulty that he could be prised out of Milan. Titian lived always in Venice, in the spacious house where Vasari would afterwards visit him, on the north side of the island, looking towards Murano and the hills of his native province of Cadore. But he often visited the Emperor when he came to Italy – in 1541, in 1543, at Asti, Busseto, Bologna – and twice at least he crossed the Alps to wait on him in Germany.

The first visit to Germany was in 1548. The Emperor was then at Augs-burg, and at the height of his power. He was at peace with France, at peace with the Turks. He was master of Italy. He had just won a resounding victory over the Protestant princes of Germany at Mühlberg, on the Elbe. It was a personal victory, for he had himself commanded the victorious army. At Augsburg he was in a position to give law to Germany. At the same time, seeing all Europe at his feet, he could turn to the great problem of Christendom, the reform of the universal Church. The Council of Trent, which he had summoned for that purpose, was in session. With him at Augsburg were other members of his family: his sister Mary of Hungary, and his brother Ferdinand, heir to the elective Empire. His son Philip, heir to his hereditary kingdoms, was not far away: the Emperor had summoned him from Spain, and he had sailed from Barcelona to Genoa. He was now at Milan, *en route* for Brussels, whither the Emperor too was bound. Philip was much in his father's mind at the time, for the Emperor was planning to entail upon him a vast and settled inheritance, a whole world at peace. It was in Augsburg, at this moment, that Charles V wrote out, with his own hand, his famous 'Political Testament' for the guidance of his son.

Such a gathering, at such a time, provided artistic opportunities not to be missed. Habsburg portraits could be painted and the glory of Habsburg victory could be made immortal. Both Titian and Leoni were called into service, and each, on this historic occasion, produced some of his finest work.

Leoni, together with his son Pompeio, had been picked up by Philip in Milan and was carried by him to Brussels; but he did not like Brussels and contrived to return to his workshop in Milan. On his way back, he was diverted to Augsburg, and held there, by his old friend Granvelle. The first work which he produced there – his first work for the Emperor – was his famous statue of Charles V suppressing Tumult, *Il Furore*. The statue expressed a well-known passage of Vergil, in which the Roman poet hails

(Opposite) Charles V
suppressing *Il Furore*;
the statue made by
Leone Leoni in
Augsburg.

his patron, the Emperor Augustus, as the statesman who has brought peace
and law to a disordered world: the gates of War, says the poet, are now
closed, and impious Tumult, bound fast with brazen chains, fumes horribly
in helpless rage.[4] Leoni also executed a bronze bust of the Emperor, wearing
the armour which he had worn at Mühlberg. Both these works clearly reflect
that recent triumph. They show Charles V as the victorious general, the man
of order, the new Augustus, who, at his Imperial city of Augusta, Augsburg,
celebrates the restoration of peace in Europe, the end of dissension in Rome.

Titian had also been to Milan to wait on prince Philip and to paint his
portrait. Then he too came to Augsburg. With him he brought two paint-
ings which he had recently finished: *Ecce Homo* and *Venus with the Organ-
Player* – the last a tribute no doubt to the Emperor's love of music; and he was
ordered to paint six new pictures for the Emperor, mostly portraits of his
family. He also painted the two Granvelles, the bishop of Arras and his
father, the Imperial chancellor. Throughout his visit, Titian had free
access to the Emperor. It was perhaps at these meetings that the Emperor,
as we are told, stooped to pick up the fallen brush of Titian. Certainly
Emperor and artist became close friends. When Titian left, Granvelle wrote
that no other parting had been so painful to his master. Back in Venice,
Titian completed his paintings and sent them over the Alps in the care of
those universal suppliers, the Fugger of Augsburg.[5] In completing them
he benefited from the advice of his old friend Aretino who suggested that
the equestrian portrait of the victorious Emperor should be embellished by
all kinds of mythological and allegorical figures. This, after all, had been
the method of Leoni. But Titian did not accept the advice. By now he knew
the Emperor well, and had discovered his true character.

Reliefs by Leone Leoni
(1509–90) of Charles V
and his wife, Isabella of
Portugal (1503–39).

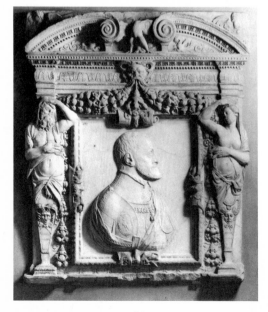
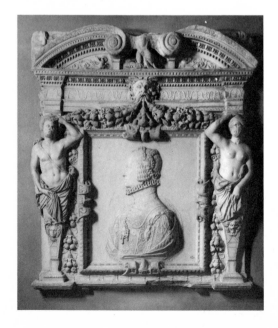

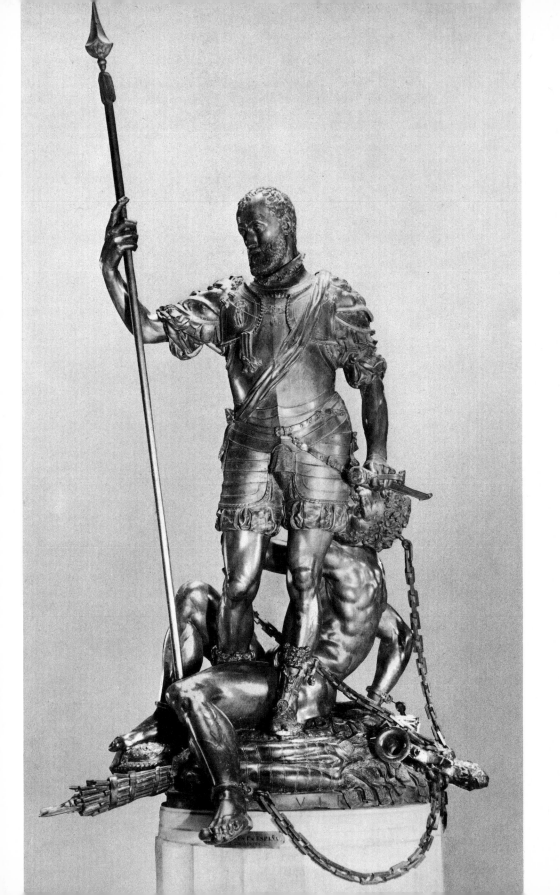

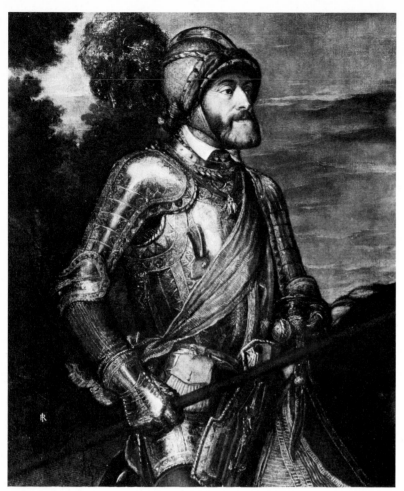

Detail of Titian's equestrian portrait of Charles V after the victory at Mühlberg, 1548.

For already, even in his greatest triumph, Charles V had become a tragic figure, and Titian, whose greatness lies, in part, in his ability to see and portray the whole personality of a man – we think of that wonderful painting of the aged Farnese pope, Paul III, and his *nipoti*, so worldly, so disillusioned, so sly, painted in Rome only three years earlier – was clearly aware of it. He shows it in the portraits which he now painted of Charles V. Here we see the Emperor, sitting alone, withdrawn into himself, in his low armchair. Who would think that this was the greatest statesman in Europe, the 'invincible Emperor' at the height of his power? Then there is the portrait of the warrior, the great equestrian portrait, also painted at Augsburg, at the same time. The victorious Emperor, mounted on the charger that had carried him to victory at Mühlberg, does not exult in his victory. He is staid, controlled, pensive, but serene. The portrait carries us back thirty-five years. It reminds us of Dürer's drawing of the knight who advances, with open visor, undeterred by Death and the Devil. He is *Miles Christianus*, the Christian Knight of Erasmus' famous work of devotion.

(Opposite) Albert Dürer: *The Knight, Death and the Devil*, 1513.

34

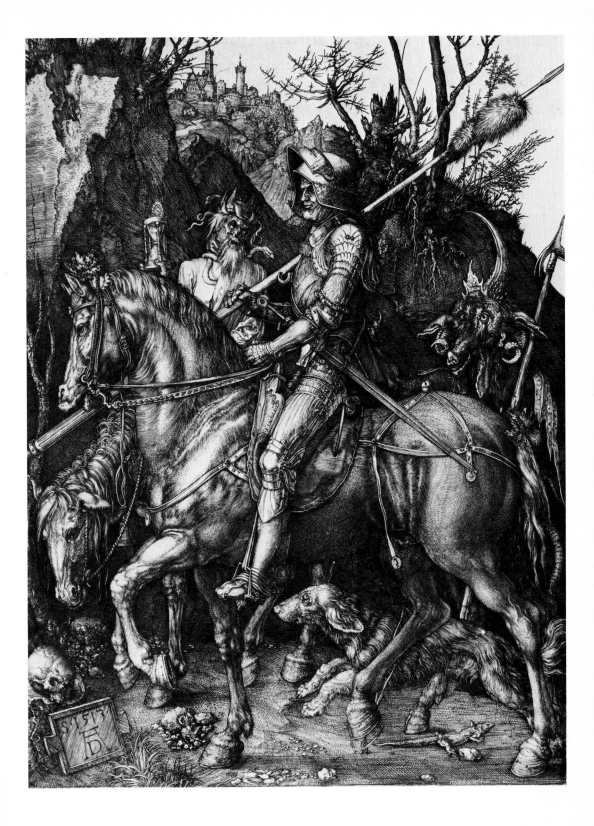

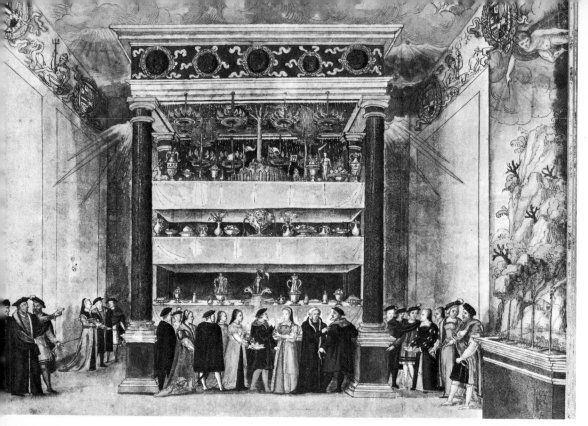

For always, in thinking of the last years of Charles V, we must remember his first years: those exciting years of pre-Reformation humanism, of the New Learning, the hope of a newly enlightened, re-christianised world. The young Emperor had been the heir to the crusading dreams of Maximilian, the Christian humanism of the Netherlands. Erasmus had been his counsellor, as he was the spiritual guide of his widowed sister, Mary of Hungary. His own court had been a centre from which Erasmian ideas had been carried abroad to Spain, to Germany, to Hungary and Bohemia, to England and Scotland. But now all those early hopes had proved vain. Erasmian enlightenment had been overtaken by Lutheran heresy, leading to revolution in Germany, discontent throughout his dominions, convulsion of established order throughout Christendom. By now Erasmus himself had died, disillusioned, in a Protestant city. His followers were being persecuted. The Emperor looked around and saw the Church still unreformed, society shaken. What real progress had there been in the thirty years since his Joyous Entry into Antwerp? Extension of empire had meant only extension of effort, multiplication of problems. The early hope had turned sour and men watched, in a mood of weary pessimism, while the world, they believed, was hastening unreformed to its predetermined doom.

And worse was to come. In 1550 the Emperor once again summoned a Diet to Augsburg. Before the Diet there was a great family conclave. The Emperor's plan was to keep his vast estates intact for the son in whom he had

now invested all his hopes, prince Philip. An elaborate compromise had been worked out. His brother Ferdinand would succeed him as Emperor – that was already agreed – but after that, Philip was to step in as next heir and thus reunite the whole inheritance. Naturally enough, his brother's son, who would thus find himself disinherited, did not agree. After long and exhausting discussions, the plan failed, and friendship was not cemented, for the next generation, between the two branches of the house of Habsburg.

Both Titian and Leoni were called to Augsburg at the time of this second great family gathering in 1551. Leoni was summoned very peremptorily by Granvelle – no doubt he had been making difficulties as usual – and was ordered to make heads of king Ferdinand and of his son Maximilian, statues and bronzes of the Emperor and his son; which he returned to Milan to do, in his own time, far too slowly, as the Emperor complained. Titian had a different commission. He was to paint a solemn devotional picture for the Emperor's death. According to Vasari, who visited Titian in his studio fifteen years later and no doubt had it from his own lips, the Emperor, at the height of his victories, told Titian that he planned to abdicate and that he wished for a picture to take with him. Such was the origin of Titian's *Gloria*: that great painting in which the Emperor, draped in a winding-sheet, kneels with the Empress in adoration of the Trinity.

That was in 1551. Next year political disappointment was followed by military disaster: double disaster. First there was the sudden overthrow in

37

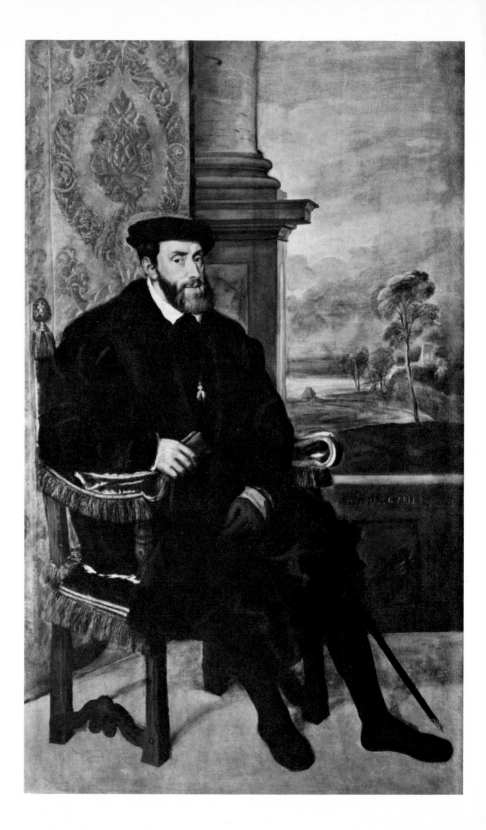

Germany, when the Protestant princes reversed the verdict of Mühlberg. Surprised by his defeat, the Emperor was forced to flee by night, carried in a swaying litter, by torchlight, over the Alpine passes from Innsbruck, and his hated minister, the indispensable Granvelle, had to abandon his pictures, including his own portrait, to be mutilated by the unappreciative German soldiers. Then there was the long-delayed revenge for the old triumph of Pavia: the victory of the French at Metz. Meanwhile, all over Europe, the religious struggle had come to a crisis. The 1550s were to prove a decisive decade in the century of the Reformation, the watershed of the century. They marked the extinction, in blood and fire, of the humanist hope, the end of the period in which men could believe in an undivided, reformed Christendom.

For fifty years the best spirits of Europe had lived in that hope. At first they had been confident, as the Emperor himself had been, for it was his generation; then, after 1530, after the climax of his political success, the tide had begun to turn. Now no one believed in reform any longer. Erasmus was dead; the Erasmian vision had faded; the reforming Council of Trent had collapsed; military victory itself had been reversed. In the 1550s a disillusioned generation turned from reform to persecution. It was then that the fires were lit throughout the west and the war of parties was fought to a finish. The Emperor himself, in those years, came to regret his early tolerance, and though he continued to nourish old Erasmians at his court, and to read the works of Erasmus in private, he became a persecutor of heresy in his dominions. These are the years of the fierce *Placards* against heresy in the Netherlands. They are also the years of the *Chambre Ardente* in Paris, the revived Inquisition in Rome, the Smithfield Fires in England, the burning of the Spanish Erasmists at Seville and Valladolid. After the fierce cautery of that terrible decade, the climate of Christendom could never be the same.

Nor could its institutions. The imperial idea, a fantasy in the mind of Maximilian, had almost become a reality in the life and work of his pragmatic grandson. But now, even in Charles' own lifetime, its unreality had been revealed. It was an archaism, a mocking phantom from the past, which had briefly seemed embodied and then had dissolved again, never to be restored. Charles V was the last universal emperor, the last Emperor to be crowned by the pope, just as his tutor, Adrian VI, was the last universal pope, the last non-Italian to reign over the universal Church. After them, Empire and Papacy dwindled together, the one to become a local Danubian monarchy, the other a sectarian Italian church.

It was in the middle of this decade of disillusion that the Emperor decided to carry out the resolution which he had already imparted to Titian and to renounce, one after another, his several crowns. The scene in Brussels is famous, one of the great set-pieces of dramatic narrative history. We are not now concerned with it: what concerns us is not the abdication of a ruler, but the retirement of a patron: for even in his retreat from glory, even as he

(Opposite) Titian's portrait of the Emperor at Augsburg, 1548.

retired to his remote monastery in Spain, the Emperor was an aesthete still, perhaps now more than ever: having shed all the cares and solemnities of power, he was determined to be accompanied by all the pictures and statues which he had collected and which he could now contemplate in peace.

Already in 1554 his plans had been made in detail. He had chosen his monastery, the monastery of Yuste in Estremadura. It was a monastery of the Jeronymite Order, that purely Spanish order, which, more than any other, had been thoroughly penetrated by Erasmian ideas. It was an old foundation, 150 years old, and like so many Jeronymite monasteries, it had been beautifully sited, in a remote rural solitude, among delightful woods and fresh water: a place, made, it seemed, for quiet Vergilian meditation. The special apart-ments for the Emperor had been planned down to the last detail. The altar of the church was to be made visible from the imperial bed, and above it, of course, was to hang Titian's great work, the *Gloria*. The other works to be brought thither were all carefully inventoried, and the paintings were to be hung, and the busts and statues placed, in carefully chosen sites.

But first of all, the statues and pictures had to arrive at the Imperial court in Brussels. Leoni, as usual, had been dilatory. In January 1554 the Emperor wrote impatiently to his governor of Milan: there were four pieces of bronze and four of marble, long overdue from that Milanese workshop: what had happened to them? In Venice, Titian too had to make excuses. The *Gloria*

Charles V's abdication at Brussels on 25 October 1555. Kneeling at his feet is his son, prince Philip; on his left is Mary of Hungary, on his right Antoine Perrenot (cardinal Granvelle), the bishop of Arras.

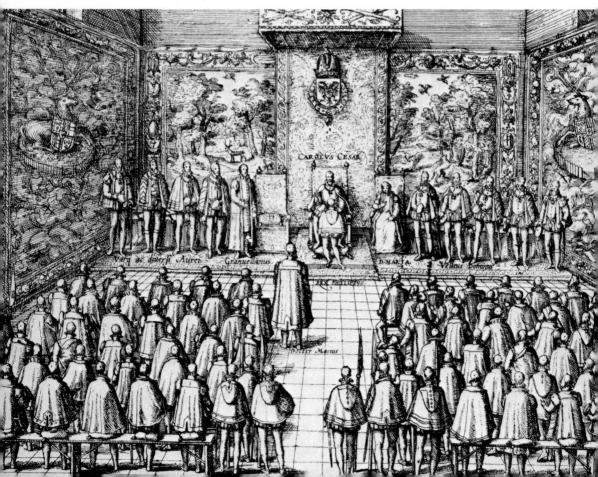

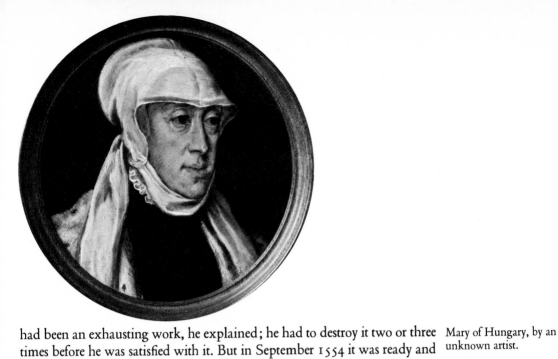

had been an exhausting work, he explained; he had to destroy it two or three times before he was satisfied with it. But in September 1554 it was ready and he was able to write to Granvelle that, 'although his Imperial Majesty is at present preoccupied by the war, nevertheless I hope that my work, of the Holy Trinity and the Madonna in Heaven, which I am sending to him, will find him in peace and glorious victory, so that with a glad heart he can rest his eyes on my painting.'[6] Leoni was slower: he was not ready for another year. Then he wrote, saying that his work was ready and proposing to bring it in person to Brussels. As the Emperor had by now planned to leave for Spain, this was not convenient, and Leoni was put off; but then the Emperor's journey itself was delayed, and Leoni was summoned to Brussels after all. So he set out, sending the marbles by sea from Genoa, the bronzes through Germany with his son Pompeio, and finally presented himself at the court in Brussels. The Emperor received him well and asked him to come with him to Spain to work for him there. Leoni pleaded illness, but undertook to send his son with the statues, which was agreed. Then he himself escaped back to Milan.

And now at last all was ready for the retreat to Spain. After the tearful scenes of abdication and farewell, each several crown was ceremonially deposed and the imperial party set sail. They took the usual route, from Flushing to Laredo, on the north coast of Spain, and thence began the long journey through Spain to the monastery at Yuste. With the Emperor went his sister, Mary of Hungary, who was also weary after thirty years of ruling the Netherlands and who also saw to it that the best of her art-treasures were not left behind. She had twenty-four Titians in her castles of Binche and Mariemont, and a marvellous collection of old Flemish masters, all of which accompanied her to Spain. Most of them can still be seen there; for it is by such accidents that great national collections, in the past at least, were built up.

Mary of Hungary, by an unknown artist.

41

The monastery at
Yuste, the Jeronymite
foundation where
Charles lived in
retirement from 3
February 1557 till his
death on 21 September
1558.

There is something incorrigibly romantic about that last journey of the
greatest ruler of his century, the first Emperor to abdicate since Diocletian
over twelve centuries before. But let us not wax too dramatic, or too pathetic
about it. As readers of Stirling Maxwell's book discover, it had its lighter
side too. Retired statesmen, when they have recovered from the immediate
effects of exhaustion, soon miss the delicious taste of power, those 'red boxes'
of urgent state documents which are the daily sustenance of their sense of
authority. Even in his retirement, the Emperor (for he could never really
think of himself as the ex-Emperor) saw to it that all the despatches of state
were still regularly sent to his ample and well-protected cell. Every day saw
him busily dictating political letters; and although various reports of his
failing health reached the outer world, those who lived with him were
surprised by his hearty Flemish appetite: indeed, the weekly courier from
Valladolid to Lisbon was diverted in order to bring, every Thursday, a
provision of eels and other rich fish for Thursday's fast. In Stirling Maxwell's
incomparable book we can read all about the menu at Yuste: those plump
partridges from Gama, those sausages to which the Emperor was particularly
partial, 'of the kind which Queen Juana, now in glory, used to pride
herself in making in the Flemish fashion, at Tordesillas', those plovers and
eel-pies which he would not miss for all the world, that syrup of quinces
which he particularly liked for breakfast, the asparagus, the quails, the
truffles . . .

However, if the ex-Emperor was a glutton for the rich food which had already ruined his stomach, he remained an insatiable aesthete, still constant in his love of beauty. His apartments at Yuste were adorned with the great series of Titians which he had brought with him, including the famous Augsburg portraits of 1548 and 1550, with the *Ecce Homo*, and, of course, with the *Gloria*, at which he gazed so long that his physician feared for his health, and the *Last Judgment*, at which he was looking when he 'first felt the touch of death'. There were many other pictures too which he had brought with him, and which, with the Titians, are the beginning of one of the great art-galleries of the modern world, the Prado in Madrid. Nor should we forget his irrepressible love for music. When he was not looking at his pictures, or dismantling and reassembling his mechanical clocks, he would be playing on the little silver-cased organ which had accompanied him on his last as on all previous journeys – the same organ which he had played in the olive groves of Tunis before the assault on the city and which is commemorated in Titian's paintings; or he would be standing at his window listening to the monastic choir which the general of the Order had specially reinforced for him, quick to correct – in somewhat military tones, we are told – any false note in that complicated Flemish polyphony.

Finally, sunk though he now was in religious devotion, submitting himself to long and curious penances, we can never forget that, *in foro interno*, he was an Erasmian still. Among his books were old Erasmian books. His confessor, who would give him the last sacrament, Bartolomé de Carranza, archbishop of Toledo and primate of all Spain, was an old Erasmian. Erasmianism, driven out of the world which, in 1520, it seemed about to conquer, had shrunk into the private cell of its abdicated and dying patron. A new generation had taken over, and that new generation had new and very different ideas.

This was soon to be made clear, even to the Emperor. In July 1558 he became impatient, once again, with Leoni, whose statues had still not arrived. Then he discovered the reason. Why, he wrote to his secretary Mateo Vazquez at Valladolid, had Pompeio Leoni, who was bringing them, been arrested (as he now learned) by the Inquisition? The secretary replied expressing surprise at the question. Pompeio had been arrested as a Lutheran heretic: he had appeared at an *auto de fe* and had been condemned to a year in a monastery – which at least was better than his father's year in the galleys. 'This happened so long ago', explained the minister, somewhat casually, 'that I assumed Your Majesty knew.' But the statues, he added, were safe. In fact the statues never reached Yuste. Two months later the Emperor was dead.

Next year the last débris of his old ideals was swept away. The Inquisitions of Rome and Spain struck together. All the works of Erasmus, without exception, were forbidden to the faithful; Dürer's portrait of Erasmus, wherever it was printed, and every other portrait of him, was ritually defaced;

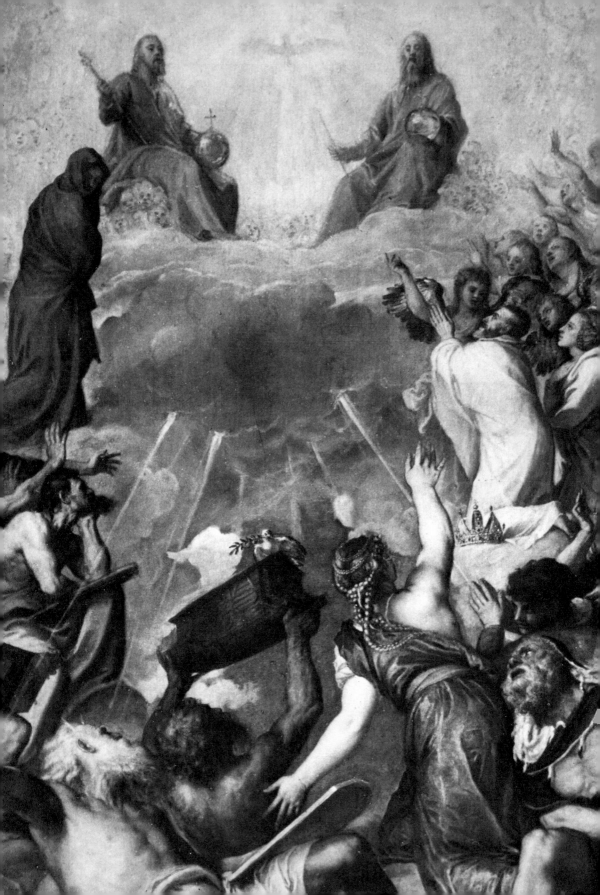

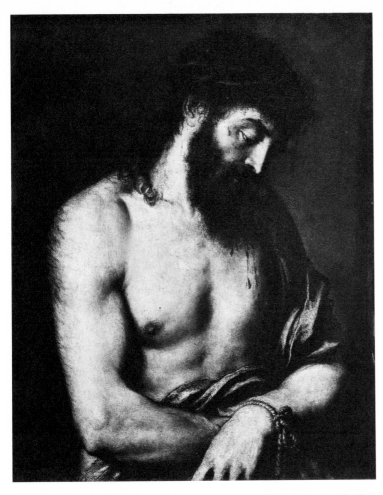

his last Spanish adherents – including one of the Emperor's former chap-
lains – were publicly burnt; and archbishop Carranza himself disappeared,
for seventeen years, into the prisons of the Inquisition. Alarmed by these events,
and perhaps, like Pompeio Leoni, sensing a personal threat, another artist,
who had accompanied the new king of Spain, suddenly took fright. This
was Antonis Mor, a native of Utrecht, who had been taken up by Granvelle,
had lived in his house in Brussels, and was described by him as his own
painter, 'mon peintre'. Mor had been employed by Mary of Hungary and
sent by her to Lisbon to paint the Portuguese royal family; he had also
painted a portrait of Philip at Brussels, and had been sent by him to England
to paint Mary Tudor. Then Philip had carried him off to Spain. But now
Mor saw the signs of danger: he turned tail and fled back to the Netherlands,
from which all the blandishments of Philip and his governors could never
persuade him to return.[7]

In these ways it was made clear that, with a new reign, a new course,
and a new attitude to the arts, had begun.

Two of Titian's paintings that accompanied Charles to Yuste: the *Gloria* (detail opposite) and the *Ecce Homo* (above).

CHAPTER 2

Philip II and the Anti-Reformation

A MAN'S INTELLECTUAL RELATION to the outer world, his philosophy, if he is capable of one, is precipitated by the impact of that world upon him when he is young. The Emperor Charles V had been young in the ex-hilarating days of humanist reform, of that Erasmian enlightenment whose failure, forty years later, would be the tragedy of his generation. His son, Philip II, the most famous king of Spain, whose reign filled the next forty years, had never known that ideal. Therefore he could not regret its failure. He had been born in Spain, had grown up in Spain, had been educated in Spain, at a time when Erasmianism was already in retreat. The battle which he saw around him, in his own time, was no longer the battle for Erasmian enlightenment: it was the battle between aggressive Spanish orthodoxy, hardened by victories already won, and the hydra which had replaced Erasmianism in Europe: Protestant heresy, social revolution.

All this must have been very obvious to Philip when he first left Spain, at the age of twenty, to visit the vast empire which, at that time, he might still expect to inherit whole and undivided. This was the journey which took him to Milan and Brussels and introduced him to Titian and Leoni. He then discovered a very painful sight. Italy, Germany, the Netherlands were all convulsed with heresy: heresy which, by now, as it seemed, could only be extinguished by fire and faggot. Fire and faggot, as he was well aware, had succeeded in Spain. It would succeed in Italy. When his marriage to Mary Tudor made him king of England, it seemed to succeed in England. It was in the terrible years of the mid-century, those years of universal repres-sion, that Philip discovered Europe, and it was then that his political conscience was formed: that remorseless, exacting, pedantic conscience that was to make him, when he returned to Spain in 1559, the unyielding champion of Catholic reaction. The great events of his reign – the revolt of the Netherlands, the civil wars in France, the war with England – would confirm him in that posture and make him, what he would become for the next three centuries, the bogeyman of good Protestants, the cold, suspicious bigot of the Escorial.

If we wish to see Philip II as a person and as a patron, we shall see him best in the Escorial. Indeed, it is difficult to see him except in that grim palace. It was his chosen home, the deposit – the deliberate, calculated, cherished deposit – of his own mind. It symbolised his politics: his ever vigilant bureaucracy, his cumbrous centralisation of government. But it

El Greco (*c.* 1545–1616), *The Adoration of the Name of Jesus*, often called 'The Dream of Philip II'.

47

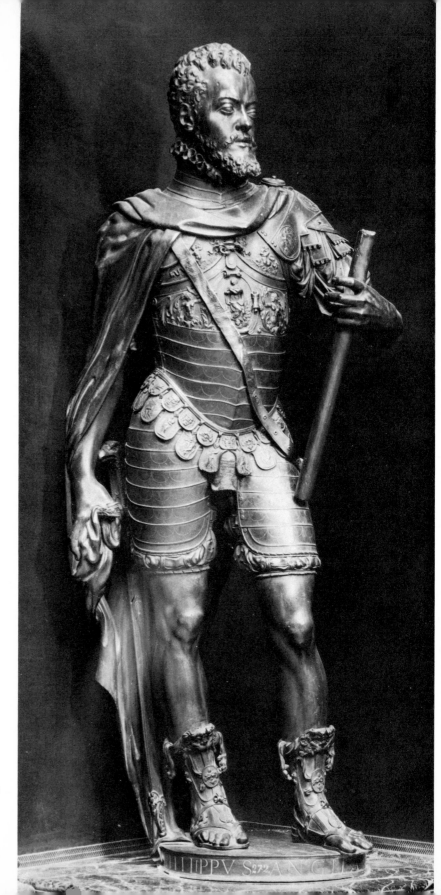

Philip II as a Roman
emperor; bronze statue
by Leone Leoni.

was also the expression of his love of art, his taste in art; and that taste in art was in turn the expression of his philosophy: a philosophy which he attempted to impose on all Christendom.

The story begins with the reign. When Philip inherited his father's abdicated crowns, as king of Spain, duke of Burgundy, duke of Milan, king of Naples, he was in Brussels, and it was in Brussels that he learned of the great victory which his army had won over the French at St Quentin on 10 August 1557. That was the day of St Laurence, the Spanish saint and martyr. To express his gratitude for victory, Philip resolved to found a church in honour of St Laurence. A year later, he was still in Brussels when the news was brought to him of his father's death in the monastery at Yuste. In his will, the Emperor had charged his son with the burial of his body and the repose of his soul.

All his life, Philip II was deeply devoted to the memory of his father. He venerated his father, with an almost religious veneration: a return, perhaps, for that genuine affection which the Emperor had invested in this, his only surviving legitimate son. Other men did not love Philip: he was cold, introverted, without frankness or charm, and deeply suspicious, trusting neither himself nor others. In his travels in Europe, he had excited universal dislike among his father's subjects. They had noted the great difference between him and his father: the one so confident, so robust, so warm; the other so anaemic, so secretive, so averse to all forms of animal pleasure: who loved neither hunting nor feasting nor battles nor bullfights. Sensing this universal distrust, Philip was doubly grateful to his father who alone offered him constant affection and support. He recognised that, in human terms, his father was a far greater man than he, and throughout his reign he strove to imitate him, and where he could not imitate, to honour. He was also painfully conscientious and attentive to detail; and, being conscious of his own insufficiency, he was apt to over-compensate in execution. He did not always take the right decisions; but whatever he decided to do would always be meticulously thought out and then applied on a huge scale. This combination of minute detail and massive application characterised all his work, whether he was designing a church or an armada, a litany or a tomb.

He showed this in his response to the events of 1557–58, and the obligations which they had imposed on him. In the end, Philip decided to meet all these obligations – his obligations to God, to St Laurence and to his father – by one single and spectacular payment, one vast foundation which would, as it were, embody the purpose of his whole reign. He would himself return to Spain. He would make Spain the centre of his empire. He would make a new capital in the centre of Spain. And in an appropriate position, to be carefully determined by himself, with expert advice – but all decisions, in this as in everything, would always be his – he would create a massive building which would incorporate a monument of victory, a church dedicated to St Laurence, a mausoleum for the Emperor and his whole

family, a monastery of religious to sing masses for their souls, a seminary for the regular supply of such monks, a palace for himself, and a spiritual and political powerhouse for the reimposition of Catholic unity throughout his dominions under the imperial power of Spain. This huge complex – which must of course, like Yuste, be a Jeronymite foundation – was what we call the Escorial. Its full title was the 'royal foundation of S. Lorenzo del Escorial'; and it was built high on the sierra to the north of Madrid.

The building of the Escorial is a story in itself. It occupied the king throughout most of his long reign. What infinite loving care he devoted to every stage and detail of it! His last librarian of it, the Jeronymite monk Fray José de Sigüenza, one of the great prose-writers of the golden age of Spanish literature, has given a marvellously full account both of the building of the Escorial and of Philip's life in it. There we can see the greatest king in Christendom personally choosing the site, personally designing the build-ings, the economy, the daily routine. For no detail was too small for the royal attention: Philip loved making small decisions, perhaps to compensate himself for his uncertainty in greater matters. He personally defined and inspected the site: it was to be far from towns, so that the monks could contemplate without interruption, and in a place which, of itself, should lift the soul in holy meditation. He took great trouble to seek out suitable relics: six entire bodies of saints, 130 perfect and over 60 imperfect heads, and thousands of odd bones. He himself ordained the size and disposition of every bed in the dormitory, every coffin in the mortuary; he counted each prayer in the church-services; he prescribed every drug in the dispensary. He also lived there himself, in his sober black habit – for he soon gave up the finery of his youth, the gay clothes in which Titian had painted him in Milan – as a monk among 'his monks', constant in his attendance at religious ser-vices. It was there, sitting in his choir stall in the great church, that he would be told, by an excited messenger, of the decisive victory over the Turks at Lepanto in 1571, the greatest, most spectacular battle in the whole history of the Mediterranean. He would then utter no word, show no emotion, only quietly, afterwards, order a special *Te Deum* to be sung. It was there that he would hear, with equal impassivity, the news of the equally decisive defeat of the invincible Armada, the greatest disaster of his reign, the most specta-cular event in the history of the Atlantic. It was there, on more ordinary days, at his desk in his private apartments, that he would dictate his endless despatches, sending pedantic instructions to his viceroys in Naples and Portugal, Mexico and Peru, his governors in the Netherlands, Milan, the Philippine Islands. It pleased him to write, as he himself expressed it, 'from this bare mountain-side from which I govern half the world with two inches of paper', with his obedient secretaries in attendance and his young daughters, whom he so loved, standing by to pour sand on the wet ink.

In many ways it is difficult not to see the Escorial, and Philip's life there, as a deliberate imitation and exaggeration of the Emperor's monastery and

MAIORA TIBI

life at Yuste. Like Yuste, the Escorial was a Jeronymite monastery – only much larger. The Emperor had lived at Yuste, among his monks, for three years; Philip lived at the Escorial, among his, for almost his whole reign. The workmen employed were the same. The essential features were the same. At Yuste, the Emperor's bedroom had been so placed that he could see the high altar from his bed. At the Escorial the arrangement was the same. Only in one detail did Philip positively reduce the scale: while the church was far larger at the Escorial than at Yuste, the royal bedroom was far smaller. But even this was, in a sense, an exaggeration: an exaggerated, a more ostenta-tious humility.

(Opposite above) Titian's *Danaë*, one of the 'Poesy' series commissioned by Philip.

(Opposite below) Titian's *Venus with the Organ-Player*.

A vast new building which was to fulfil all these functions and to express a whole philosophy, needed the assistance of the arts; and Philip, whose tastes were so personal, and so emphatic, and who watched over and decided every detail, inevitably expressed himself in them too. For like his father, he was a connoisseur, a genuine lover of all the arts: of architecture, painting, music.

His first opportunities had been supplied by his travels abroad, in Italy and in Flanders. In Italy, as we have seen, he had met Titian and had been painted by him. Like his father, he had been bowled over by Titian. He had written to him in the most friendly terms, addressing him as 'fiel y amado nuestro', 'faithful and beloved friend', and had commissioned from him not only his own portrait, to be sent to England for his prospective bride Mary Tudor, but also a series of enchanting pagan scenes. This series was probably inspired by the wonderful series which Titian had painted for Alfonso d'Este, duke of Ferrara, thirty years before – that series which contains the famous *Bacchus and Ariadne* – and which Philip must have admired, since it had no ideological content, with a pure, disinterested, aesthetic admiration. The new series was known as 'the Poesy', and consists of eight paintings representing scenes from the *Metamorphoses* of Ovid. Philip commissioned them for his palace in Madrid; today the series is broken up and the individual pictures, scattered by Philip's heedless successors, are distributed over two continents.

Like his father, Philip also loved music, especially organ music. In Titian's painting of *Venus with the Organ-Player*, the organ-player has the features of Philip. When he went as king to England, he took with him his own organist, his teacher António de Cabezón, to cheer him in that barbarous land. As for architecture, the Escorial itself would show his imperious taste, and his philosophy.

Philip's spartan bedroom in the Escorial.

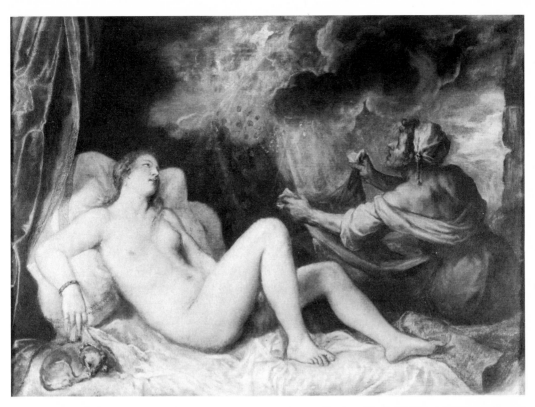

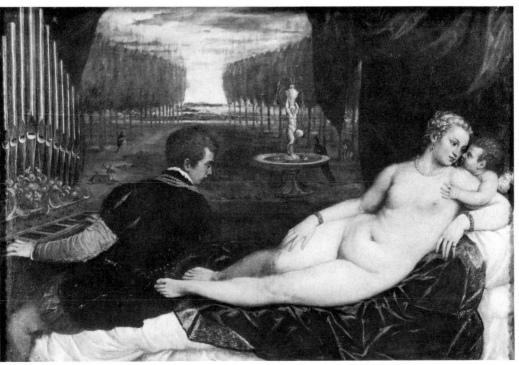

For it was Philip himself who inspired and directed the architecture of the Escorial. There were professional architects of course. The first was Juan Bautista de Toledo, a Spanish architect employed by the viceroy of Naples and recommended to Philip, while he was still in Brussels, by his father, the Emperor. Toledo was a universal Renaissance man, well versed in Greek and Latin, mathematics and philosophy. He had studied in Rome and worked, under Michelangelo, on St Peter's. Philip appointed him *maestro mayor*, master of the works, and it was he who began the building; but he did not last long or leave a distinctive mark on it. His plans were often changed, and he died in 1569. Then he was succeeded by his assistant, the man who, far more than he, is generally regarded as the architect of the Escorial. This was Juan de Herrera.

Juan de Herrera is probably the most famous of all Spanish architects. He is the man who imposed a new style, called by his name, on all Spain. But he was not elevated to the position held by his predecessor. He did not become *maestro mayor*. That post was left vacant. Philip himself was now in charge, and what he wanted, as Herrera's modern biographer says, was 'an architect who would faithfully interpret his own judgment and fulfil his orders with scrupulous accuracy and without the slightest discussion. Only in mere technicalities and formalities was he to enjoy any liberty.'[1] For after all, Herrera had not been trained as an architect at all. Like so many of the great architects of the Renaissance, he was a complete amateur. By training he was a humanist scholar and mathematician who had accompanied Philip on his travels, served the Emperor in court and camp, and whose only known work, until Philip told him to build this vast ambitious palace in the sierra, was not a work of architecture, or even sculpture: it was a manuscript – a fair copy of a medieval astrological treatise made for the education of Philip's unfortunate son, don Carlos.

And what was Philip's own conception? Architecturally the character of the Escorial is clear. It marked the end of the style which had flourished during the last century: the composite 'plateresque' style, with its mingling of gothic and classical, of Flemish decoration and Italian form. The Emperor, with his Flemish background, had loved the plateresque style, and his reign has been seen, by some, as the period of its triumph in Spain. But now, with brutal suddenness, all that ceased, not only in the Escorial, but throughout Spain. To Philip, the plateresque, the 'primitive baroque' of Renaissance Spain, savoured too much of frivolous Flemish liberty; and with one firm order he extinguished it throughout his dominions. All who have studied the architecture of Spain, from Richard Ford to modern Spanish scholars,[2] have been struck by the suddenness of the change. It was a change not only of style but of ideology. Just as Erasmianism, brought south by the Flemish court of Charles V, had permeated the receptive Spanish church, and created, for a generation, a new religious spirit, subtle, elusive, cosmopolitan, so immigrant German craftsmen had infused a northern spirit into Spanish

architecture and created, as it seemed, a new national style. But just as the Spanish church had struck back, decisively, against the one, so the Spanish king struck back, equally decisively, against the other. Perhaps the change would have happened anyway; but the iron will of the king, *el rigor filipino*, would not allow a gradual evolution. He spoke, and it was done. The geometrical severity of the Escorial was the architectural corollary of the fierce *autos de fe* of Seville and Valladolid.

For in architecture as in religion, Philip knew well what he wanted. Instead of plateresque luxuriance, he demanded a return to Roman gravity, Roman decorum, the qualities which the great artists of the Italian Renaissance had re-created. It is true, these qualities were now under attack in Italy, and in Rome itself, by a frivolous subjective school of 'mannerists' (as we now call them);[3] but the old ideals were still maintained by some of the ageing giants – by Michelangelo in Rome and Titian in Venice – and it was

The monastery palace of San Lorenzo del Escorial; an engraving of 1587.

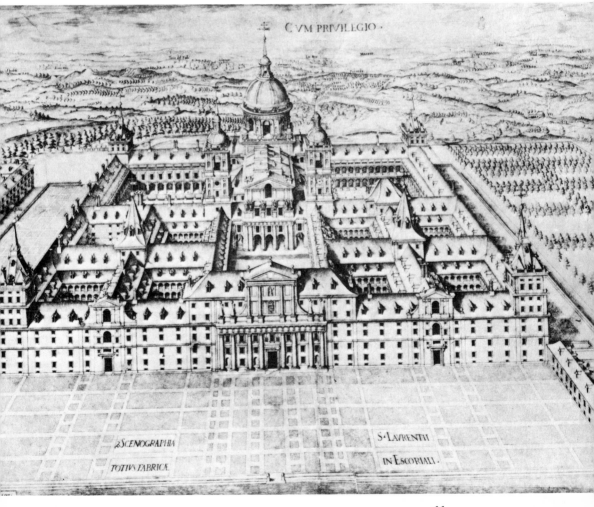

CVM PRIVILEGIO

SCENOGRAPHIA

TOTIVS FABRICA

S·LAVRENTII

IN ESCORIALI.

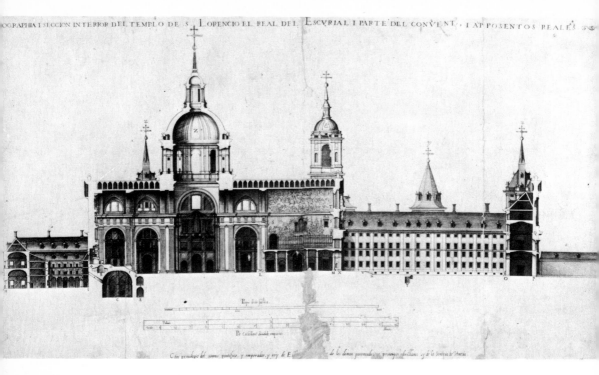

The church of the Escorial; cross-section engraving by N. Perret, 1587.

to them, or to their disciples, that Philip now turned. The church of the Escorial would be based on the same system as Michelangelo's plans for St Peter's, in which Toledo had collaborated;[4] Michelangelo was himself at first proposed as the artist who should design the Emperor's tomb, as he had already designed those of the Medici popes;[5] and who but Michelangelo's disciple, Titian's friend, Leone Leoni, and his son Pompeio, should be called in to produce the bronze statues of saints and kings for the high altar and the cenotaph? Who but Titian himself should paint the great altarpieces for the church of St Laurence?

Stare super antiquas vias: to stand firm in defence of ancient values, ancient austerity, Roman simplicity, that was the philosophy of Philip II. It was a philosophy which he applied in art, and in architecture. He even applied it in music. Just as the frivolities of plateresque architecture, or mannerist art, were to be banished from the Escorial, so the frivolities of Flemish polyphony were to be banished from its music. The Jeronymite monasteries of Spain had a tradition of polyphony, of popular Spanish airs, or *villancicos*, which were worked even into religious music. The Emperor, at Yuste, had enjoyed such secular music. But here too Philip dissented from his father. At the Escorial all such things were banned. There the offices, Philip ruled, were to be sung in plainsong only. And, as always, Philip not only banned: he smothered, flattened, obliterated the heresy beneath a massive weight of stone, size or sound. In the single church of the Escorial there were to be no fewer than eight organs: seven new organs specially built by the most famous

56

organ-builder in Europe, Gilles de Bregos of Antwerp, as well as the Emperor's portable organ, fetched from Yuste and placed in the sacristy; and the monastic establishment was ordered to provide a constant supply of musical monks so that all these organs could play at once, filling that great church with devout but severe sound.

This extremism, this exaggeration of effort, characterised all Philip's actions. Whenever he made a bid, it was always a shut-out bid. What was the point of being the richest, strongest king in Christendom if one did not make use of one's pre-emptive power? So Philip would always have gigantic buildings, invincible armadas, whole charnel-houses of relics, continuous national orgies of prayer; and when he died he did not hesitate to pre-empt Almighty God himself. In his will he ordered that there should be sung, in all the churches of his dominions, 30,000 masses, all at once, and as soon as possible. '30,000 masses, and all at once!' exclaims a sceptical French historian. 'Was ever such violence done to Heaven? Surely this is an intolerable egotism, to claim for one's self so many other human lives. . . .'[6]

'An intolerable egotism . . .' Yes, again and again, under the self-conscious outward humility of his character, we see the raging egotism which knows that it can afford such humility. It is an egotism which required absolute conformity, absolute obedience: a cannibal egotism, for it gobbled up all lesser egotisms, as the Escorial gobbled up Yuste, and all its contents –

Charles V's portable organ.

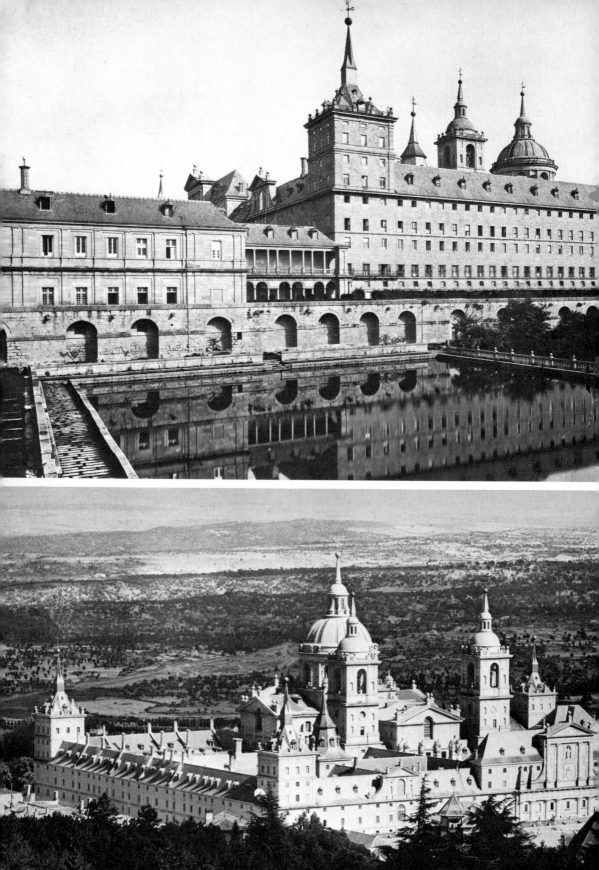

Two views of the Escorial.

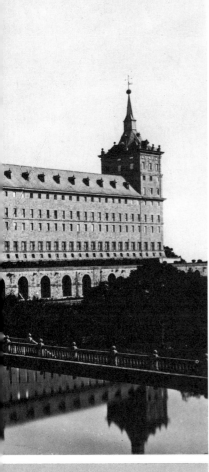

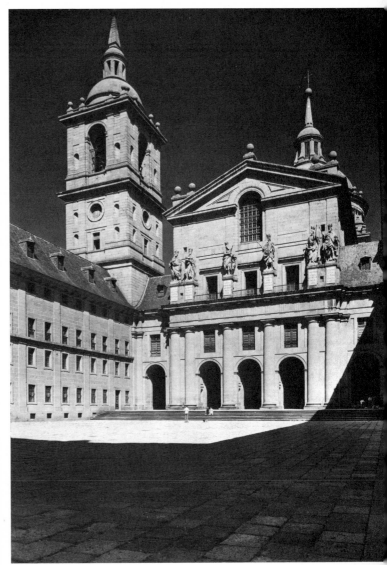

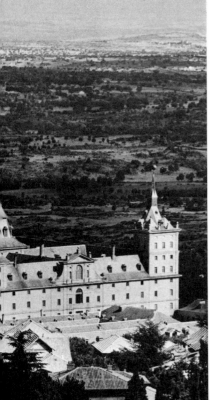

The Court of the Kings in the Escorial.

the Emperor, his pictures, his organ, all torn from his chosen resting-place, with its ancient peace and privacy, its quiet garden and running water, its walnut and sweet chestnut trees, to be re-sited, or re-exhibited, like trophies of conquest, in this cold, gigantic new mausoleum. When Philip visited Yuste, for two days in 1570, he would not sleep in the Emperor's room, out of respect for his father: he slept in a closet which adjoined it 'so narrow that it would scarcely contain a little bed'.[7] The same respect did not prevent him, three years later, from sacrificing his father to his own ostentatious new foundation.

And not only his father: all his dynasty – that is, all the Habsburgs of Spain – were to be dug up and re-entombed in this grandiose family monument. That indeed was one of its functions. The ceremony of their re-entombment, in 1574, was, in a sense, the official opening of the Escorial.

It was a strange, spectacular ceremony. Philip, whose mind loved to dwell equally upon detail and upon death, planned every stage of it in person. Eight royal corpses were to rise from their several graves and travel, with sepulchral slowness and religious ceremonialism, over the long, melancholy plateau of Spain. There was the corpse of the Emperor, brought from Yuste to this more magnificent variant of Yuste. There was the corpse of the Empress Isabella, his wife, and of the infante don Fernando, his second son, brought from the far south, from the chapel-royal of Granada, where the bodies of 'the Catholic Kings', Ferdinand and Isabella, not being Habsburgs, were left in peace and still lie, magnificently entombed. There was the corpse of the queen, doña Juana, the Emperor's mother, brought from the north, from Tordesillas, where she had spent most of her life, a certified lunatic. No doubt it was from her that both the Emperor and his son had acquired their macabre tastes: for in her brief personal reign she had travelled from place to place with her husband's coffin, bringing out the corpse and burning candles around it in her bedroom every night. There was the corpse of doña Leonora, the Emperor's sister, queen of France, brought from the west, from Talaveruela, on the borders of Portugal; and there were the corpses of his sister Mary of Hungary, and of his third son, the infante don Juan, and of Philip's own first wife doña Maria of Portugal, who all came south from their tombs in Valladolid. So from north and south and west the three funeral processions, led by bishops and swollen with monks, clergy, royal officials and all their retinues, horses and mules, brought the heavily draped catafalques through deferentially mourning villages to converge on the Escorial; and there, in a terrible tempest – that demonic wind of the Escorial which seemed so ominous to the monks – they were finally deposited in the plain, subterranean vault which Philip had prepared for them. The most impressive vault was that of the Emperor, on whose wall Philip caused to be inscribed the record of his filial piety: 'If any of the posterity of Charles V should surpass the glory of his actions, let him take this place: otherwise, bow and withdraw.'[8]

The coffins of
Charles V, Philip II,
Philip III and Philip IV
in the Escorial.

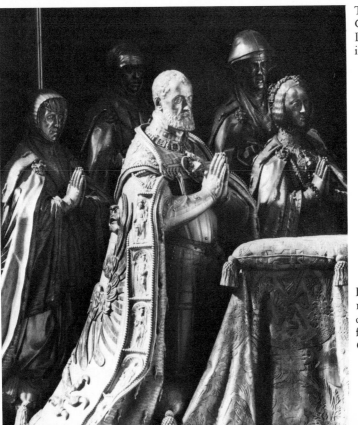

Pompeio Leoni (1533–
1608), praying figures
of the Emperor and his
family at the tomb of
Charles V in the Escorial.

After the architecture and the music, let us return to the pictures. For of course the altars and the apartments of the Escorial had to be decorated. The news that the king of Spain, the greatest of royal patrons, was building a huge palace naturally spread through the world of art, exciting high hopes. The client princes of Italy were eager to oblige their overlord, the papal families of Rome knew whom to please, Spanish ambassadors abroad had their orders. Above all, the king himself had his views. Naturally enough he turned, first of all, to Titian, whom he invited, through his ambassador in Venice, to paint the *Martyrdom of St Laurence* for the central altar of the church of the Escorial. Titian was now an old man – at least seventy-five years old – and could hardly be fetched to Spain, but he did paint and send numerous works including a St Laurence. Philip also angled for Tintoretto and Veronese, but they too refused to come to Spain. No doubt they had heard of the difficulties of Pompeio Leoni and Antonis Mor. They preferred to live outside the reach of the dreaded Spanish Inquisition.

To the end, Philip continued to rely on Titian. After the great victory of Lepanto, in 1571, Titian painted for him his pictures *The Allegory of Lepanto* and *Spain Coming to the Aid of Religion*. He was still painting for him in 1576, when plague came to Venice and carried off the great artist at the

Titian's *Spain Coming to the Aid of Religion*, painted for Philip II after the battle of Lepanto.

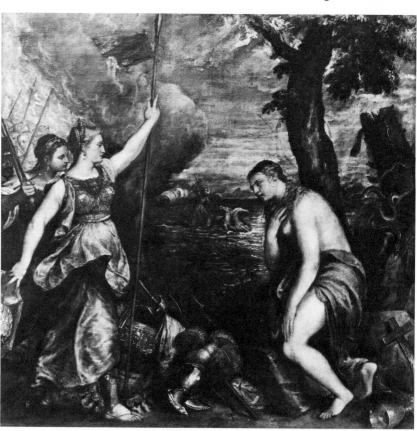

age (according to his own calculation) of ninety-nine. Titian's own calcula- tion, we now believe, was excessive, but not by much. Anyway, it is well known that painters improve with age.

In the year of Titian's death, Philip was excited by a new opportunity. One of his client princes, the grand duke of Tuscany, offered him, for the Escorial, a particularly choice marble statue. This was the life-size *Crucifixion* which Benvenuto Cellini had lovingly made for his own tomb, but which the grand duke's predecessor had wheedled out of him. Philip accepted the offer with delight. He looked forward with excitement to the arrival of the statue, and when it came – it was the first statue to arrive at the Escorial – he offered to set it up in the place of honour. Its arrival was celebrated like the coming of a great prince; no expense, no ceremony was spared; and it was carried from Madrid to the Escorial with the utmost care, by fifty human porters; for the king would not entrust so precious a work to mere mules. But when it was unpacked and could be scrutinised, Philip's enthusiasm faded: the statue, he now discovered, had neither *gravedad* nor *decoro* – gravity and decorum, the two qualities which, to him, were so essential. On the contrary, it was pagan, sensuous, even voluptuous. It was also naked. The pious king covered the sensitive area of the marble body with his hand- kerchief, which afterwards, we are told, was long preserved as a relic. Then he sent it to a dark chapel behind the choir and its intended place was left to be filled, in due course, by a more suitable *Crucifixion*, by the faithful family firm of Leoni and son. Thus Leone Leoni, still irremovable in Milan, scored a last victory over his old rival, Benvenuto Cellini.[9]

Head of Christ (left) from the life-size *Crucifixion* by Benvenuto Cellini (1500–71). (Right) *Crucifixion* in bronze by Leone and Pompeio Leoni.

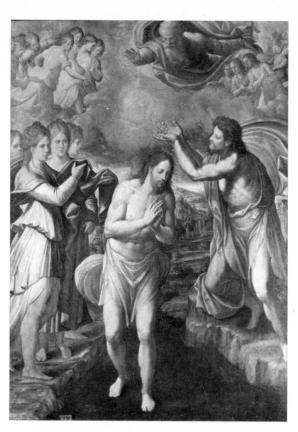

Thus still, in 1576, we find Philip relying on his father's artists, Titian and the two Leoni. Was there then no new talent for a new generation? Philip was certainly eager to find such talent. His governors and ambassadors combed Italy. But alas, the great days of Italian art seemed now to have passed. 'We have no painters at hand here as in the *Pays d'Embas* [that is, the Netherlands]', wrote cardinal Granvelle, now ambassador in Rome, 'for Titian at Venice is now very frail and Michelangelo is dead, and after them I see none better than we can find in the *Pays d'Embas.* . . .' No doubt he was thinking of Antonis Mor, *mon peintre* who, however, absolutely refused to leave Antwerp for Spain. Fortunately, at this very moment, when Italy seemed so blank and infertile, a native Spanish painter arrived at court, bringing with him, as his *prueba* or sample of work, a painting of the baptism of Christ. This was Juan Fernández de Navarrete, a native of Logroño who had studied in Italy under Titian himself, and who was known, since he was a deaf-mute, as *el Mudo*.

Philip liked el Mudo's work: he found in it, says his chronicler, 'a peculiar grace in the preservation of *gravedad y decoro*': precisely those Roman qualities which the Escorial was intended to enshrine, and which the new Italian mannerists sacrificed to an affected elegance. So el Mudo was taken on, and for the next eleven years worked there, with a team of otherwise unknown

64

Italian artists. It was because they were unknown that these Italians were willing to come to a country which seemed to them at best grim and dull, at worst dangerous, and whose atmosphere at court, as a Venetian ambassador wrote, 'is cold as ice'. But el Mudo was often ill and absent, and then, in 1579, he died, and Philip had to seek a substitute. It happened that a substitute was immediately available. That substitute was the greatest artist of his generation, the only painter of unquestioned genius between Titian and Rubens. Moreover, he was already at hand, in Spain. We recognise him, though a foreigner, as the first great painter of Spain. He was the artist whom we all know by his Spanish nickname, *el Greco*, the Greek.

For a Greek genius to appear in western Europe in the sixteenth century is at first sight surprising. Greek history, it seemed, was now over. The Byzantine empire had been destroyed a century ago by the Turks. Greek culture, the Greek nobility, the Greek intellectual élite had been extirpated. The Greek Church was reduced to the catacombs. But there was still a slender remnant of Byzantium which lay outside the Turkish empire thanks to earlier Venetian conquests. In the Dalmatian coast, in the Illyrian islands, and above all in Crete, a continuous tradition of Greek culture survived. Moreover, in the sixteenth century, in these limited areas of Venetian rule, and especially in Crete, there was a renaissance of Greek art and letters. Cretans, educated in Venice, taught Greek to Italian humanists, corrected texts for Erasmus and the Aldine press, sustained the Greek Church in its captivity. The only famous Greek work of literature in that century, the poem *Erotokritos*, was written in Crete; the only famous Greek churchmen and theologians came from Crete; and there was, in Crete, a flourishing school of Byzantine painting in which one Domenico Theotokopoulos was trained. Domenico Theotokopoulos was our el Greco. He was a recognisable Byzantine painter before he came, like every ambitious Cretan, to Venice, and, having worked there in the studio of Titian, went on, in search of patronage, to Rome.

In Italy, el Greco never became an Italian. He remained to the end of his life a Greek, a lover of the Greek classics, of Greek philosophy, and his friends and mentors in Italy still came from his own Greco-Illyrian world. In Venice he was influenced by the Dalmatian Franjo Petrić, better known as Francesco Patrizi, the most admired of neo-Platonic philosophers, whom the Church would ultimately condemn. In Rome he was patronised by the Dalmatian miniaturist Jure Clović, better known as Giulio Clovio. Clovio, at that time, was established as one of the artists working in the Farnese palace – that splendid palace which pope Paul III built out of the ruins of the Roman Colosseum – and he introduced el Greco too into that great centre of Roman art-patronage. There el Greco drew attention, as always, by his genius and singularity. He painted a self-portrait, we are told, which 'astonished all the painters of Rome', but which is now lost. He also astonished them by his effrontery. One day he was employed, with other

artists, to clothe with decent paint the naked figures of Michelangelo's *Last Judgment*: for already Counter-Reformation prudery was the rule at Rome. El Greco arrogantly suggested that Michelangelo's whole work be destroyed; then, he said, he would himself replace it with another version that would be just as good and more decent. At this, we are told, all the painters and lovers of art in Rome were very shocked, and el Greco 'had to go off to Spain'. Thirty years later, in Toledo, el Greco would be recorded as saying that Michelangelo was 'a good fellow, but did not know how to paint'.

In fact it did not need the indignation of the Roman artists to drive el Greco to Spain. Already king Philip's talent-spotters in Italy had their eyes on him, and he was eager to go. He went there in 1575, or thereabouts. We do not know whether he went first to Madrid or Toledo; but it does not matter. We know that he was in Toledo, painting altarpieces for the refounded church of S. Domingo el Antiguo; and between Toledo, the old capital of the Church, and Madrid, the new capital of the state, there was a natural connection. The archbishop of Toledo, primate of all Spain and inquisitor general, was a royal minister. All the canons of Toledo came from the grandest Spanish families. Whoever was known in one city was known in the other. El Greco may have worked anonymously in the Escorial, just as el Mudo worked also at Toledo. He certainly worked for the archbishop and dean of Toledo. It may well be that his first work in Spain was the famous painting of Philip II bowing the knee, with all things in heaven, in earth and under the earth, before the Holy Trinity, and that this painting was the *prueba* which he offered to the king to attract his patronage.[10] Clearly it is based on Titian's *Gloria* and would be as appropriate in the Escorial as the *Gloria* had been at Yuste – although that *Gloria*, of course, had by now, like the Emperor himself, been taken out of Yuste and thrust into the all-devouring Escorial.

At all events, in 1580, el Mudo being dead, Philip decided to give el Greco his chance. In the church of the Escorial he had designed a chapel of St Maurice, the captain of the legendary Theban Legion, whose entire body he had been lucky enough to acquire. The saint, like the legion, was spurious; but the body was real, and had been placed in a coffin richly overlaid with gold, silver, and jewels; and now the king wanted an altarpiece which would commemorate the collective martyrdom. This el Greco was invited to produce. A contract was duly made out; and the king, with his customary attention to detail, wrote that el Greco was to be given an advance of money and all the paint he needed, 'especially ultramarine blue', for he wanted the work completed – as he always wanted others to do everything, as he himself never did anything – 'as quickly as possible'.

Unfortunately, when el Greco produced the finished work, in November 1582, it was not well received. 'His Majesty', as the royal librarian José de Sigüenza afterwards recalled, 'did not like it; which is not saying much, for few do, although they allow that it is skilfully done, and that its author knows

(Opposite) El Greco, *St Maurice*.

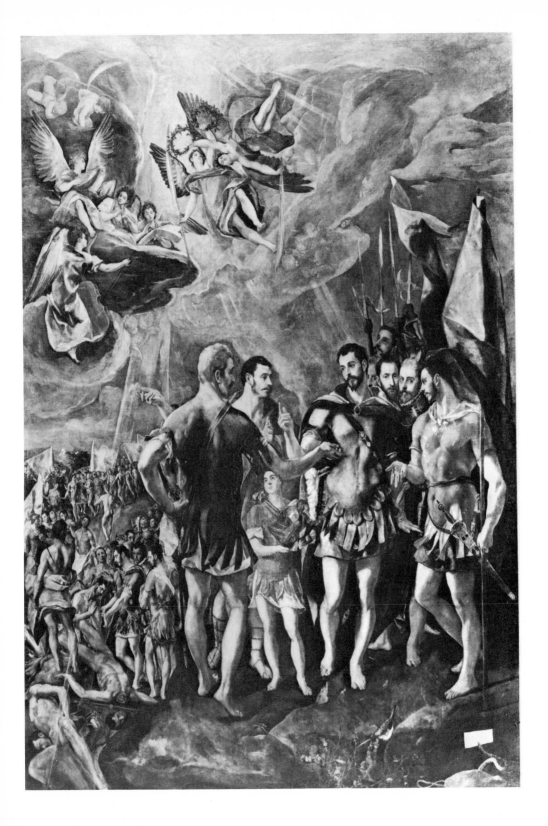

much, and there are excellent things by him to be seen.' The trouble was, he added, that this picture did not comply with the laws of reason and nature, as true art should, nor did it encourage prayer, which must be the principal aim and effect of painting. In all these respects 'our Mudo' was better. So the work was exiled to the chapter-house and another painter was commissioned to produce a more acceptable altarpiece. Nor were any other paintings by el Greco commissioned for the Escorial, or – as far as we know – by Philip II.

Such was the sad end of the long effort, by the greatest Catholic painter of his time, to capture the patronage of the Most Catholic King. In retrospect, we can see that the failure was foredoomed. Philip II was not a man who devolved any decisions, in politics or in art. He was also a man who loved to decide details. Just as, with his own hand, he would minutely regulate the disposition of the hospital beds in the Escorial, or the sailors' berths in the Armada, just as he would carefully ration the Andalusian wine in his ships, or dole out the ultramarine paint to his artists, or specify, in exact detail, how his pictures were to be packed for carriage, so he would correct the prose style of his ambassadors and the composition of his artists. For in all these matters he had a taste of his own. And his taste was very different from that of el Greco. Not for him the open-ended mysticism, the uninhibited self-expression which el Greco consecrated and transformed into an almost ethereal religious intensity. Not for him the mysterious Byzantine use of space – the aerial lobes that distinguish the separate theatres of his great cosmological constructions and are so disturbing to those accustomed to the exact mathematical measurements of the western tradition. Educated in the west, accustomed to the concrete detail, the rationally ordered structure of Renaissance art, Philip shrank from this strange, abrupt style which violated *gravedad* and *decoro* and looked forward, past the trivial elegance of mannerism, to the heroic tensions, the agonies and the ecstasies of the baroque.

So el Greco returned to Toledo and spent the rest of his life there, painting his great altarpieces for local churches, his portraits of private patrons, and his panoramic views of that clerical city. There he lived, proud, reserved and independent to the end. Like his old master, Titian, he lived majestically. The twenty-four apartments which he hired from a Spanish nobleman were stacked with paintings and with file copies, in miniature, of all his work; he had a fine library of Greek classics and Renaissance poetry; and hired musicians played to him at his meals. He charged high for his work and spent high, but his friends were few and still mostly Greek. He still talked Greek with them, read Greek, signed his name in Greek. In the Escorial he was remembered rather distantly as 'one Domenico Greco, who now lives in Toledo, where some excellent works of his can be seen'.

With the failure of el Greco, Philip was left with his obscure Italian painters; but in 1586 they were joined by another famous painter whom the Spanish ambassador in Rome had discovered and recommended. He was

Federigo Zuccaro, the academic high priest of Italian mannerism, a confident and pretentious painter whose works were highly prized in France, Germany and England, and who was now employed, as Clovio and el Greco had been, by those universal patrons, the Farnese family. Philip seized the opportunity. He appointed Zuccaro *pintor regio* with a salary of 2,000 gold ducats a year; and when the happy artist arrived at the Escorial, with five assistants, his fame was such that, as one of the monks drily recorded, 'we all but went out to meet him with a palanquin'. Once installed, Zuccaro was deferred to in all things, and allowed to choose his commissions. He chose to paint a great altarpiece for the church – yet another version of the martyrdom of St Laurence – and various other works, including ninety illustrations of Dante's *Divine Comedy*. But when the paintings were finished, 'little of it pleased the king, or anyone else'; and within three years of his appointment, he was sent back to Italy with a golden handshake and a pension. 'We must not blame him', said the king tolerantly, 'but those who sent him to us'; and he ordered Zuccaro's frescoes to be expunged and his pictures painted over, or exiled to side-rooms where he himself would never see them. Zuccaro, Philip concluded, was really only fit for the pope who, as he often complained, had no understanding of religion and had to be continually put in his place.

It is perhaps just as well that Philip, who had very firm views on the proper place of the pope in relation to the king of Spain, did not see some of Zuccaro's most valued paintings for the Sala Regia of the Vatican. He would not have been pleased, for instance, by the picture of the prostrate Emperor Henry IV humbly kissing the toe graciously extended to him by the insolent vicar of Christ, pope Gregory VII. For that matter, it is probably just as well that the pope did not see some of the works of art which were being produced in Catholic Spain. I think particularly of the new version of Leone Leoni's statue of Charles V triumphant over *Il Furore* which an unknown artist created for the duke of Alba. This was a work in painted wood entitled 'the duke of Alba destroying the enemies of king Philip II'. It is in the manner of St George slaying the dragon. The dragon is a three-headed monster, and the three heads are vivid likenesses. They are the elector of Saxony, queen Elizabeth and, unmistakable in his triple tiara, the pope.[11]

After the disaster with Zuccaro, Philip did not despair. He had in his service another Italian artist, Pellegrino de Pellegrini, called Tibaldi, a Lombard who had been his architect in Milan, but who (according to Sigüenza) had not touched a paintbrush for twenty years.[12] That, as we know from the call to Herrera, would not have troubled Philip, who never lacked the courage to speculate. So Tibaldi was now summoned to Spain, appointed court-painter, paid handsomely, and put to work, with three other artists, on the main cloister and the library. For the next eight years, from 1588 to 1596, he painted huge frescoes and countless details, repeating the five great canvases which Zuccaro had so infelicitously executed. And as he painted, this last royal artist – 'one of the most distinguished pupils and

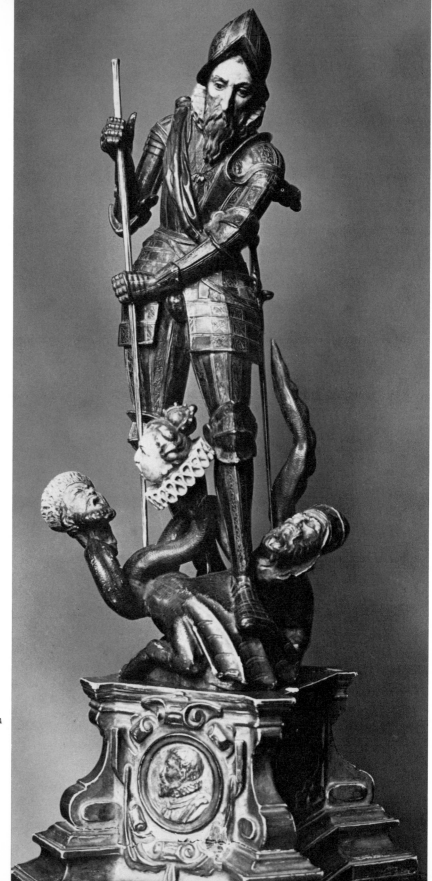

The duke of Alba
overcoming Philip II's
enemies – queen
Elizabeth, the pope and
the elector of Saxony; an
anonymous polychrome
wooden statue recalling
Leone Leoni's bronze
of Charles V
overcoming *Il Furore*
(cf. p. 33).

followers of Michelangelo', as the devout chronicler calls him – always felt the king at his elbow, instructing him which saints or heroes or historical scenes were to be included, determining the exact proportions, modifying the details. No doubt this occupation distracted the king from the tiresome public events of those eight years: the destruction of the Invincible Armada, the total failure in France, the loss of Holland, the sack of Cádiz by the English, the famine and the plague. When his work was finished, Tibaldi returned to Milan in glory. He was rewarded with a capital of 100,000 escudos, the title of marquis, and the feudal lordship of his native town. He did not enjoy these benefits long, for he promptly died. But he had served Philip well. Two years later, when the king also lay dying his long, hideous and painful death, borne with such marvellous courage, such Christian resignation, such stoic fortitude, he could feel that, thanks above all to Tibaldi, one at least of his ambitions had been fulfilled. The huge palace which surrounded him, and of which he occupied only a minute cell, but which, in its megalomaniac size and exact detail, was so exact a deposit of his personality – indeed, so peculiarly his that no other king of Spain would live in it, but it would remain to this day a cold, gigantic museum of the house of Austria – was at last complete.

And yet, was it really complete? Was this really what Philip had intended? Is not Tibaldi, in the end, something of an anticlimax? When we look at those huge frescoes, it is difficult not to agree with the judgment expressed by the incomparable Richard Ford: 'vast in size, mediocre in drawing, very little mind agitates the mass, and we chiefly carry away the desire never to see them or their like again'. And then we ask ourselves whether Philip's taste, his whole philosophy, was not perhaps anachronistic; whether this great patron and lover of art, and indeed of science, this collector, and promoter and judge of books, paintings, sculpture, was not really a man out of tune with his time, in love with a lost age, which he tried in vain, by mere authority, to recapture, and which eluded him still; for it had passed, and left him only with perverse unsatisfying phantoms.

Albert Speer, Hitler's architect, the builder of the gigantic palaces and stadia and public monuments of the Third Reich, once told me that the moment of truth dawned on him, as an architect, during the war, when he went on leave to Spain and there saw, for the first time, the Escorial. Seeing it, he realised (he says) that his own work, conceived on a similar scale, was fundamentally hollow and empty: mere monumental grandeur without a soul; while the vast building before him somehow still seemed animated by a spirit which transcended mere human vanity and could thus sustain and elevate that huge burden of stone. This no doubt is a telling judgment on Speer's architecture, but what does it tell us of the Escorial? What in fact is the spirit which informs that huge work?

It is sometimes said that the Escorial is the expression of the spirit of the Counter-Reformation of which Philip himself was the secular champion.

I am afraid that I cannot quite agree with this statement, for I do not believe that the Counter-Reformation, as that term is generally understood, really corresponded with the ideals of Philip or was willingly forwarded by him. The Counter-Reformation, in its original inspiration, was an Italian movement which, like all living movements, drew upon, absorbed, and converted into its own sustenance some at least of the new ideas which, frontally, it challenged. It captured, absorbed and transformed something of the new humanism, the new Erasmian mysticism of the time; and it was thanks to these new ideas, recovered for traditional Catholicism and incorporated into it, that the Roman Church was able to reconquer some of the provinces, and some part of the world of thought, which had been lost to Protestantism. In art, the expression of the Counter-Reformation is the triumphant baroque style of the next century: that style which, geographically, dominates the areas then recovered for Catholicism – Flanders, Bavaria, Austria, Bohemia; and what is that style, structurally, except the classic regularity of the Renaissance given a new mobility, a new energy, a new elasticity, a new spirit of dynamism and confident strength? But Philip was not a man of the Counter-Reformation, thus understood. The Spanish church did not absorb Erasmianism. It looked with intense distrust upon the mystics whom afterwards it would claim as its great glory. If Philip, late in his reign, used the forces of the Counter-Reformation in politics, it was always hesitantly, reluctantly, suspiciously. Rather, he was a man of the Anti-Reformation. He looked not forward but back: back to the serene mental world of the high Renaissance, as yet undisturbed by heresy.

He showed this in his taste in art. His great artists – Titian, Leoni, Toledo – were inherited from his father. As they died out, he could find no successors

Pellegrino Tibaldi (1527–96), a design for one of the frescoes of the Escorial, with notes by Juan de Herrera.

in their mould. Mannerism had come, Roman mannerism, the expression of a world that was self-conscious, introspective, evasive, ill at ease. That majestic, untroubled style of the high Renaissance, with its effortless dignity and gravity, was past, and in the new age no great artist could repeat conventions which were no longer spontaneous. By his iron will, through his agent Herrera, Philip could impose upon Spain a rigorous, anachronistic architecture. But when he came to decorate it, the artists were no longer there. Having refused el Greco, the one great genius of the age, who came and offered himself, and having repudiated Zuccaro, who was pressed upon him, he had to be content with second-rate artists, who, for all their docility, were mannerists still.

But let us not think of Philip II as a patron only. He was also a collector; and if he was frustrated as a patron of living artists, because living artists would no longer realise his ideal vision of the world, he could satisfy himself as a private collector of old masters who would do so. Of these he had a great collection, built up partly by inheritance, partly by purchase, occasionally by confiscation. As well as his father's pictures, and those of his great-aunt

A detail from Tibaldi's frescoes in the Library of the Escorial.

73

Margaret of Austria, he inherited the noble collection of his aunt, Mary of
Hungary. Some of these, of course, stayed in the Netherlands, in the palaces
in which they were hung; but those Philip particularly liked he fetched
to Spain. There, outside Madrid, in the palace of el Pardo which his
father had begun to build as a Spanish equivalent of the Fontainebleau of
François I, Philip created a new gallery in which favoured visitors could see
the public part of the royal collection. The idea of such a museum had been
suggested to him by one of his father's courtiers, Diego de Guevara. Guevara
was himself a cultivated man of the Renaissance, a collector of coins and
pictures, a humanist and a scholar. He had travelled abroad with the
Emperor, and had accompanied him to Tunis. In his old age, he wrote
Commentaries on Painting; and when he died, in 1570, Philip bought up the
greater part of his collection. In the Pardo Philip also placed the formal family
portraits made for him by Antonis Mor and by Mor's disciple, the Portuguese
artist Alonso Sanchez Coelho. Unfortunately, the collection at el Pardo did
not last long: most of it perished in a disastrous fire in 1604. But those paint-
ings which Philip personally most admired escaped the blaze: he had had
them transferred to his palace in Madrid, or to the Escorial.

By confiscation, Philip acquired several works of art in the Netherlands, from the 'rebels'. He also acquired one fine Spanish collection. This was the collection of his own secretary, the famous António Pérez.

António Pérez was a travelled man, educated in Flanders and Italy, who had acquired luxurious and sophisticated tastes. In the days of his power, he lived in outrageous magnificence, and he had a famous picture-gallery including, inevitably, several Titians. But in 1579 Pérez fell from power. He had tried to blackmail the king over a particularly nasty murder which they had concerted between them. Philip did his best to destroy Pérez; but Pérez was a resourceful man, who could defy and elude the power not only of the king but also, when the king called it in to help, of the Inquisition. Weak from torture, he escaped from the royal prison in Madrid; condemned to death, he escaped from the clutches of the Inquisition in Zaragoza; and in his last years, as an exile in England and France, he created and published the Black Legend of Philip which has prevailed for centuries. Philip's only revenge for this great humiliation was the confiscation of Pérez's fortune and, particularly, of his pictures, which made a substantial addition to his own collection.

Alonso Sanchez Coelho (c. 1531–88), portrait of the infanta Isabella (1566–1633), daughter of Philip II and Elisabeth de Valois, afterwards ruler of the Netherlands.

Jan van Scoreel (1495–1562), *Adam and Eve.*

(Opposite) Joachim Patinir (*c.* 1485–1524), *St Jerome* (detail).

And what was Philip's own taste in these old masters? When we ask this question, we discover that, here too, it was very Burgundian. He had no interest in fifteenth-century Italian painting: the artists of the Quattrocento are entirely missing from his collection. On the other hand he was a collector of Netherlands art, both early and late. In 1549, when he first visited the Netherlands, he bought all that he could of the works of Jan Scoreel. He delighted in the mysterious, haunting works of Joachim Patinir. Above all, this collector who in public demanded such solemnity, such order, such austere gravity in all things, privately loved the bizarre fantasies of the strangest and most tantalising of all the Netherlands artists, Hieronymus Bosch.

76

Hieronymus Bosch (c. 1450–1516), detail from *The Hay Wain*. The pope and the Emperor follow the hay wain; behind them come the sins of Greed and Vanity.

Philip had early opportunities of discovering the works of Bosch, who had been patronised, and whose works had been valued, by his Burgundian ancestors. Margaret of Austria, in particular, had collected them. The courtier, Diego de Guevara, who clearly influenced Philip's taste, was also a collector of them: six paintings by Bosch, including the famous satire *The Hay Wain*, were among the paintings which Philip bought from his heirs. Philip also sent to Bosch's birthplace, 's Hertogenbosch, where there were numerous works by him, and bought what he could; and he had other works by Bosch confiscated for him. One came thus from the palace of William of Orange in Brussels and another was seized by the duke of Alba from the nearby country-house of Jan de Casembroot, another 'rebel', and sent to the king. Philip also bought individual works privately in Spain: *The Garden of Earthly Delights*, for instance, from the prior of the Order of St John. Since the prior was an illegitimate son of the duke of Alba, this too

may have been the spoil of the Netherlands. In short, he acquired everything by Bosch that he could lay hands upon. In 1574 he sent nine of his works to the Escorial, and he had twelve in Madrid and twelve in el Pardo; and he still went on collecting. Another set of paintings was sent up the hill in 1593, five years before his death. Many of these works were afterwards lost, through neglect or fire, or during the Napoleonic invasion of Spain – that destructive, predatory invasion which was the greatest artistic disaster in Spanish history. Even so – since Bosch was out of fashion when the great museums of Europe were formed – Madrid still has the finest collection of Bosch's paintings in the world, and this, as Max Friedländer writes, 'is largely due to the taste of Philip II' who concentrated them in his personal collection in the Escorial. There they furnished his private apartments, so that he could sit and meditate at the table whose painted top portrayed the all-seeing eye of God discovering, in turn, the seven deadly sins. Philip's fascination with the works of Bosch emerges even from his letters to his little daughters. Writing from Lisbon in 1582, where he had gone to be crowned as king of Portugal, he expresses his regret that his daughters could not be with him to watch a Portuguese religious procession in his parish. They would have enjoyed it, he thought, 'although there were in it some devils which I think might have frightened you, like those in the pictures of Hieronymus Bosch'.[13]

Bosch's painted table top, *The Seven Deadly Sins* (centre detail).

Invidia

Avaricia

What was it that Philip so loved in the paintings of Bosch? Why did he Detail from Bosch's *Last Judgment.* wish to contemplate, in his private rooms, those bizarre canvases filled with strange symbolism of monstrous figures emerging from broken eggshells, incomplete, fantastic forms, weird half-animal machinery and mechanised animals, and gleeful devils toasting naked bodies in lurid, fuliginous flames? It is not quite what we expect from one who was otherwise so insistent on Roman austerity, geometrical symmetry, *gravedad* and *decoro*. Was it that he found them spiritually elevating? Did they perhaps minister to his obsessive passion for detail? Or was there a deep psychological reason: did his love of order and formality spring really from an inward turbulence which that order was needed to repress, but which these consecrated fantasies served to purge? I shall not try to answer this question, but will only quote the remark of Philip's librarian at the Escorial, the Jeronymite monk José de Sigüenza, who, of all men, best understood his royal master's mind. There are some people, says Sigüenza, who are so foolish as to think that Bosch was a heretic; which is absurd, for if that were so, the king would never have had his pictures near him. No: Bosch is a devout and orthodox satirist of our sins (Opposite) Details of Envy and Greed from Bosch's *Seven Deadly Sins.* and follies: what distinguishes him from other painters is that while they seek to paint men as they outwardly appear, 'he has the courage to paint them as they really are'.[14]

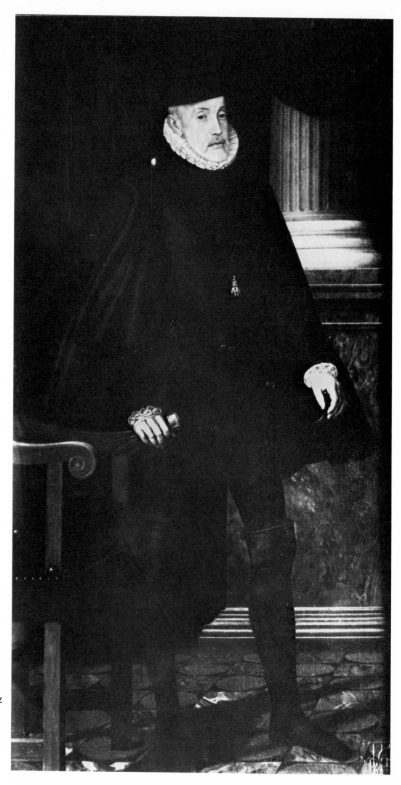

Juan Pantoja de la Cruz
(*c.* 1551–1608),
portrait of Philip II in
old age, wearing the
collar of the Golden
Fleece.

With that enigmatic remark we may leave this most enigmatic of great kings; but before forgetting him, it is tempting to look at that brilliant last portrait of Philip in his old age, by the Spanish painter, Juan Pantoja de la Cruz, which arrests us in the library of the Escorial; and then, perhaps, recalling his stoic courage and genuine love of beauty, we may think more kindly of him than did that genial extrovert, Richard Ford, whose account I shall end by quoting; for it is always a pleasure to quote that wonderful *Handbook for Travellers in Spain*, even when one disagrees with it, as one sometimes must. Pantoja's portrait, says Ford, 'is full of identity and individuality; here we see him in the flesh and spirit, lowering from his den, with Medusa head that petrifies: his wan, dejected look is marked with the melancholy taint of his grandmother' – that is, Juana the Mad; – 'observe his big grey eyes, cold as frozen drops of morning dew; note the cadaverous chilliness, which even the pencil of Titian could not warm. The grave seems to give up its dead, and the suspicious scared bigot walks out of the frame into his own library.'

That, of course, in vivid terms, is the standard nineteenth-century picture of Philip II, at least in Protestant countries, the picture which was given currency by the disgraced and exiled António Pérez, before Gachard had rehumanised him by publishing his private letters or Carl Justi had elevated him above politics with his pioneering essay on Philip II as a lover of art.

CHAPTER 3

Rudolf II in Prague

WE HAVE SEEN PHILIP II, the Most Catholic King, standing firm against the Reformation, in art as in politics, though with limited success. We are now to turn from Spain to Austria, from the elder to the younger branch of the house of Habsburg: that is, from the descendants of Charles V to the descendants of his younger brother Ferdinand. For in the course of that great family conclave at Augsburg in 1550, Ferdinand had managed to preserve for his heirs the original eastern part of the Habsburg inheritance: an inheritance which they would continue to rule long after the elder branch had died out in Spain. In fact, they would rule it for 350 years.

This eastern empire, as transmitted by Ferdinand to his descendants, was, in one direction, more extensive than that of Charles V had been, for Ferdinand, even before his succession to the Empire, had acquired two additional kingdoms in eastern Europe. These kingdoms, which would have a great influence on the Holy Roman Empire – indeed would ultimately transform its whole character – were Hungary and Bohemia.

In 1526, at the disastrous battle of Mohács, king Louis II of Hungary, the last of his dynasty, had been defeated and killed; his capital, Budapest, had been taken by the Turks; and the royal treasures of Hungary, including the incomparable library of king Matthias Corvinus, which had inspired the Medici library in Florence, had been dissipated and destroyed. After this terrible blow, the widowed queen of Hungary, Charles V's sister Mary, had returned to Brussels and would never go back to Hungary. She spent the next thirty years as viceroy of the Netherlands, where we have already caught glimpses of her. Her tastes, like those of her brother the Emperor, were robust and various. Stirling Maxwell describes her as a 'sporting dowager', and quotes an English ambassador who met her out hunting 'as she galloped into Tongres after three days in the saddle'. We have been more concerned with her as a lover of art, a builder of exquisite palaces in Belgium, a collector of Flemish paintings, a patron of Titian, Antonis Mor and Jacques Dubroeucq. Meanwhile the crown of Hungary, which was elective, had been voted by the Hungarian estates to her brother Ferdinand, as the nearest heir of her husband. But as yet it was a crown without much substance: for most of Hungary was now in Turkish hands. It would have to be reconquered; and it would not be reconquered in his time or in his century.

More important than Hungary was Bohemia. The crown of Bohemia had also been worn by the fallen king Louis of Hungary. It too was elective. It too was transferred to king Ferdinand. Thus when Ferdinand succeeded his

Jan Brueghel, detail from *The Allegory of Hearing*, showing the clocks which were one of the varied interests of Maximilian II, Holy Roman Emperor from 1564 to 1576, as of Charles V and Rudolf II.

85

brother as Emperor, the overlord of the German princes, he had already reigned for thirty years over two non-German kingdoms. All three crowns, the Imperial crown and the crowns of Hungary and Bohemia, were in theory elective; but in practice all three would, from now on, remain permanently in the family. Thus, from the time of the abdication of Charles V, there was built up, behind the forms of the old medieval Holy Roman Empire, which was essentially German, the substance of a new Danubian monarchy which, in the end, would replace it and survive it by more than a century: for while the Holy Roman Empire would be abolished by Napoleon, the Habsburg monarchy of Austria, Hungary and Bohemia would last until 1918.

This separation of the two branches of the house of Habsburg, and this extension of the eastern branch into Hungary and Bohemia, were to have immediate consequences. First, there was a personal consequence. The separation itself had not been painless. The son and grandson of Ferdinand would always remember that their Spanish cousins had sought to disinherit them; and this led to mutual distrust so long as Philip II, the intended beneficiary, was alive. Secondly, the extension into eastern Europe would sharpen the ideological problems and transform the philosophy of the Austrian Habsburgs. They would no longer share the unitary world-view of Charles V. After the 1550s – always we come back to that terrible decade – the view from Vienna and Prague no longer resembled the view from Madrid.

At Madrid, Philip II might continue to stand firm for the Church. In Catholic Spain, wielding almost absolute power, with the finest army in Europe and the growing resources of the Indies, he could afford to do so. In Austria, Ferdinand had neither the same wealth nor the same power, nor perhaps the same will. He lacked the Catholic monomania, the *rigor filipino* of his nephew. The problems which he faced also demanded greater flexibility. Externally, the great problem was posed by the Turks who, year after year, sent their armies up the Danube, almost to Vienna. To repel the Turks, Ferdinand had to rely on the German princes or the estates of Hungary and Bohemia. But the German princes were not very reliable vassals. They were jealous of their independence; they did not feel directly threatened by the Turks; and they declined to vote money for the defence, or the recovery, of the Emperor's new kingdom of Hungary, which was not part of the Empire. Moreover, half the German princes were now Protestant. Bohemia had been Protestant, in its own way, before Luther. Hungary was half-Protestant now. Whatever their personal inclinations, the Emperors after Charles V had to remember that all their crowns were elective, not hereditary. With Protestant electors in Germany, Hungary and Bohemia, they could not afford to join their cousins in Spain as uncompromising champions of the Catholic Church. When they did, in the next century, they plunged Germany into thirty years of fearful civil war.

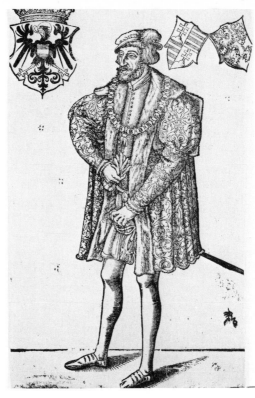

Fortunately, in these years, there was no need to take sides. By a singular good fortune, Germany had escaped the terrible repression of the 1550s, which polarised passions in western Europe. Defeated in the end by the Protestant princes, Charles V, before his abdication, had agreed, by the Peace of Augsburg, to a programme of peaceful co-existence in Germany. He regarded this as a great reverse. In fact, it was, while it lasted, a great blessing to Germany: it gave the country seventy years of prosperity, free, if not from ideological divisions, at least from ideological war. In those years the Imperial court could hardly adopt a unitary religious character. Its myth must be dynastic, even personal. Already in the sixteenth century, the century of religion, as afterwards in the nineteenth century, the century of nationality, the ruler of a multi-religious, multinational empire was obliged to appeal to a purely personal loyalty: his subjects, since they could not be patriots of the faith or the nation, were to be 'patriots for me'. As for ideology, the only ideas which would not divide his subjects were ideas which avoided narrow religious formulation: which lay outside, or above, or below doctrinal orthodoxy. Such ideas could be found in German and Italian humanism, in science, in the study of nature, in Platonic philosophy. These ideas were common to Europe. They had preceded the Reformation. Elsewhere, in times of religious war, they had been overtaken, and either smothered or distorted, by ideological passion. In Germany, during the long years of the Peace of Augsburg, they might still be free.

These facts were appreciated by Ferdinand I, whose long apprenticeship had been spent protecting the hereditary Austrian lands of the family and the sensitive eastern frontier of the Empire. It was he who, in 1530, had fixed his residence in Vienna, and thus began the conversion of that city into an Imperial capital. In that exposed position, constantly threatened by the Turks, he built no great palace; but he rebuilt the citadel, collected books and coins, founded a great library, drew together scholars, painters, architects, scientists, fostered the study of nature. Like his brother, he was a good Catholic, but he too was a humanist, of the pre-Reformation humanist generation. He was, said a Venetian ambassador, 'a most curious investigator of nature, of foreign countries, plants and animals'.[1] In the *Kunstkammer* which he created, he collected especially coins of the Roman Empire. All the humanists of the Renaissance looked back to the Roman Empire, and none more nostalgically than the humanists of the house of Habsburg; for was not the Holy Roman Empire, which they ruled, a continuation of the pagan Roman Empire – which incidentally, when it was christianised, kept the Church, which it had established, firmly in its place?

A silver bell, ornamented with natural details cast from living models, which was commissioned *c.* 1558 by the Emperor Ferdinand I from the Nuremberg silversmith Hans Jamnitzer (1538–1603).

The ambiguous ideological position of the Vienna Habsburgs was made even clearer by Ferdinand's son Maximilian II. Maximilian succeeded his father in 1564. He too was a humanist, a 'universal man', a friend of scientists and scholars, a lover of antiquity and nature, a botanist, a bibliophile, a student of foreign, even oriental languages. How different from his hated cousin Philip II, who refused to learn foreign languages and shut himself up behind the double barrier of the Pyrenees and the Escorial! Maximilian's wide interests were reflected in a passion for collecting. In his search for antique statues and modern pictures he employed his own ambassadors abroad – and other kings' ambassadors too. He fetched artists and architects from Italy to rebuild the royal castles in Bohemia, grew exotic plants in their gardens, and made a menagerie for wild beasts at Ebersdorf. One of the architects whom he tried to capture was the greatest architect of the Italian high Renaissance, Andrea Palladio himself. Like his uncle Charles V, he loved clocks and music, especially organ music. In 1567, when the fanatical puritan friar who had become pope as Pius V planned to abolish 'figured music' in the Church, Maximilian saw his chance and nearly captured Palestrina for his court.[2] That would indeed have been a catch, for Palestrina, though dismissed, as a layman, from St Peter's, was still the glory of Roman and Catholic music: he was choirmaster of the two great Roman churches of St John Lateran and Sta Maria Maggiore. The Emperor, on the other hand, was regarded in Rome as no better than a Protestant: did he not keep a Protestant court-preacher and have many Protestant friends? In 1576, when the Emperor lay dying, these suspicions seemed to be confirmed. Though pressed on all sides – by his wife and sister, by the papal legate and the Spanish ambassador – Maximilian refused to die in the approved orthodox manner. He would neither confess nor receive communion as a Catholic. 'The wretch has died', the Spanish ambassador wrote sourly, 'as he has lived' – as a crypto-Lutheran.

Indeed, religious orthodoxy seems not to have interested Maximilian II. What did interest him were the arts. One of his favourite artists was that strange figure, Giuseppe Arcimboldo of Milan, 'the prince of illusionists and most acrobatic of painters' as he has been called. Arcimboldo had worked in north Italy and had there been employed by the Emperor Ferdinand in his capacity as king of Bohemia. Ferdinand liked his work and, at the end of his life, fetched him to his court. There Maximilian spotted him and secured him as his own official portrait-painter. In the reign of Maximilian, Arcimboldo became a great favourite at court, the arbiter of elegance, the organiser of festivals and musical functions. His *forte* was in painting grotesques, allegories and symbolic figures, and especially 'composite heads': bizarre portraits ingeniously constructed out of animal, vegetable or mineral forms. We are told that Maximilian one day ordered him to portray the court-doctor whose face was ravaged by the effects of venereal disease. Arcimboldo composed an unmistakable likeness out of animals and cooked fish, which was a huge success. After that, there was no stopping him, and the courtiers and

The Emperor
Maximilian II; a
woodcut of 1566.

court servants were all 'composed' in turn, including the librarian, composed out of books, and the cook, made out of frying-pans and sausages.

A more serious artist patronised by Maximilian – for no one can really take Arcimboldo seriously – was the famous 'mannerist' sculptor Giovanni Bologna, whose virtuosity of elegant movement has been repeated by thousands of copies throughout the world. Bologna was a Belgian, trained at Bergen, near Mons, in the studio of Jacques Dubroeucq, the architect and sculptor of Mary of Hungary. He was then taken up by that universal patron cardinal Granvelle, who sent him to Rome. Thence he passed to Florence, where he was captured by the grand duchess of Tuscany. The grand duchess was Maximilian's daughter, and so Giovanni Bologna moved into the Imperial orbit. Maximilian tried hard to lure him away from his son-in-law to Vienna, but the grand duke was determined to stop that. He reluctantly raised Bologna's salary and forbade him to leave Florence. Bologna sent duplicates of his works to the Emperor, so that Austria and Bohemia, like Tuscany, were enriched by exquisite waterworks and fountain-statuary.

90

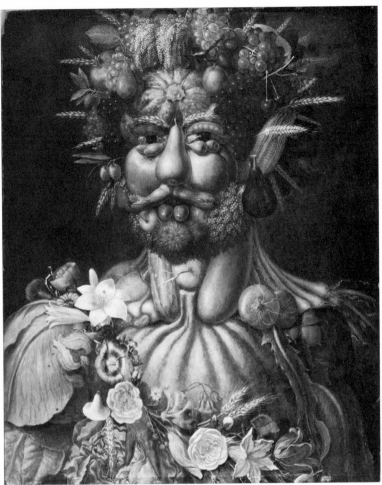

Giuseppe Arcimboldo (c. 1530–93),
Rudolf II as Vertumnus (above) and
The Cook. Both these pictures were
among the many art treasures looted
by the Swedes during the Thirty
Years War.

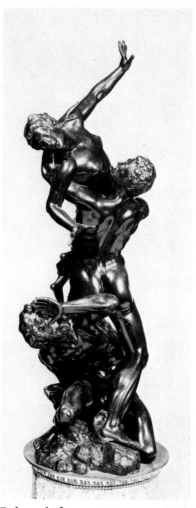

Bologna's famous *Mercury*, poised on one toe on a wind-god's breath, now
in the Bargello in Florence, may have been first designed for the Emperor.
But the imprisoned artist could not follow his offerings. He was kept firmly
in Florence, lucky if he was allowed to perform occasional works for approved
friends and allies of his patrons – for the dukes of Mantua and Bavaria, the
Austrian archdukes, cardinal Granvelle – but unable himself to go abroad.
He sometimes complained bitterly of his fate, held in Florence by the parsi-
monious grand duke while his pupils (he complained) became rich abroad,
'and I think that they laugh at me, for having preferred to serve His Serene
Highness when I have been offered handsome contracts in Spain and in
Germany with the Emperor'.

In his last years Maximilian planned a new *Lustschloss*, or palace with
pleasure-gardens, the *Fasangarten* near Vienna; and since he could not lure
Giovanni Bologna himself from Florence, he asked him to recommend a
painter and an architect who could undertake such a work. Bologna obliged

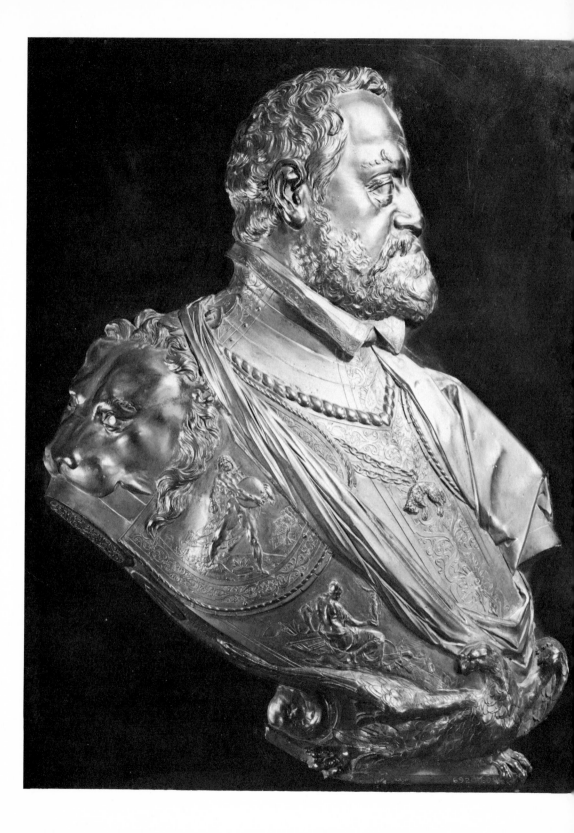

by sending two young men who were then working in that great centre of Italian art-patronage, the Palazzo Farnese in Rome. One of them, the architect, was Bologna's pupil and fellow-countryman, Hans Mont of Ghent; the other, the painter, was Bartholomäus Spranger of Antwerp. Spranger was a brilliant draughtsman, unrivalled – like Giovanni Bologna in his own medium – in representing vivacity and grace of movement. He had worked in Parma and fallen under the spell of Correggio and Parmigianino; then he had come to Rome and had been brought into the Palazzo Farnese by the miniaturist Giulio Clovio, whom we have met as the friend and early patron of el Greco. Clovio had been attracted by a picture of a Witches' Sabbath which Spranger had painted for an unappreciative patron and which he was thus able to buy for himself.

We may recall incidentally that it was precisely at this time – about 1575 – that el Greco left the Palazzo Farnese on his way to Spain and it is fascinating to speculate what would have happened if he had been directed, not to Madrid but, as he so easily might have been, to the other Habsburg court in central Europe and had spent the rest of his life not in solitary independence at Catholic Toledo but in court favour at semi-Protestant Vienna or Prague. Would his strained, elongated figures have been more acceptable in those 'mannerist' circles, or would his exalted religious ecstasy have left him a misfit there too? We would then have had no *Burial of Count Orgaz*, no storm-laden panoramic scenes of Toledo, perhaps none of those miraculous altarpieces so impregnated with intense religious feeling. What substitute could Imperial patronage have supplied, for such a loss? Perhaps we should be grateful for the accident that sent el Greco to Spain and the disappointment that greeted him at the court of Philip II.

As it was, Spranger and Mont accepted the call. They set out from Rome and arrived in Vienna. But their arrival proved ill-timed. Scarcely had they reached the city when Maximilian died and they found themselves stranded, without a patron, at least until the pleasure of the new Emperor should be known. Fortunately for them, the new Emperor, Maximilian's son, Rudolf II, was a ruler who was to continue his father's patronage and become the greatest collector of the whole house of Habsburg – as well as an eccentric whose enigmatic personality has tempted novelists and dramatists, and has bewildered historians from his own time to ours.

Like some other crowned aesthetes – like Charles I of England or Ludwig II of Bavaria – Rudolf II was not a successful politician. His long reign – he reigned for thirty-six years, from 1576 to 1612 – ended, like theirs, in deposition and disgrace; and historians, who tend to see the past through its sequel, have judged him severely. Was not his reign merely a long period of ideological paralysis, or at least incubation, in which time stood artificially still, and was lost, while the predestined events of the next century were being slowly hatched? What did Rudolf do to face those events? Why did he not see them coming, take sides, hurry them on? But such retrospective views are essentially

Rudolf II, Holy Roman Emperor from 1576 to 1612; a portrait-bust in old age by Adriaan de Vries (c. 1560–1626).

Portrait of Rudolf II's friend, Heinrich-Julius, duke of Brunswick-Wolfenbüttel, by an unknown artist.

unhistorical. Every age, as Leopold von Ranke wrote, is 'immediate to God'. We do not blame queen Elizabeth for not foreseeing or forestalling the English Civil War. The Rudolfine age, like the Elizabethan age, is an age in itself; it had its own philosophy, its own inner springs; and that philosophy – in its motivation, if not in its form – is perhaps more intelligible to us, who live in a world of ideological tensions and ecumenical aspirations, than to our predecessors who looked for signs of 'progress' and identified progress with particular parties in politics and ideas. Recently, scholars have recognised the legitimacy of such an approach, and have sought to reconstruct, objectively, the 'world picture' of the later Renaissance. One of them, Mr Robert Evans, has addressed himself particularly to the mysterious, esoteric world of Rudolf II. But for his work I would hardly venture to tread on such difficult ground.

96

Was Rudolf a Catholic or a Protestant? To him, so blunt a question would have seemed somewhat unreal; for he came, like his father, from the humanist pre-Tridentine world which had not yet made that permanent distinction, and which the Peace of Augsburg had artificially prolonged in the German lands. When he first succeeded his father, the Catholic Habsburgs of Spain were pleased: they thought that they could be sure of him. Had he not been educated in Spain, for eight crucial years, in the purest Spanish orthodoxy – for at that time it had seemed that he might be the heir to the Spanish throne? On his return from Madrid to Vienna, his Austrian subjects had found him completely spaniolised in dress, manner, speech and religion. At the funeral of his father he had introduced that Spanish magnificence and formality which Charles V had brought from Burgundy to Spain. Soon after his accession, he had given further evidence of orthodox zeal: he had used his Imperial authority to block the Protestant advance in the Rhineland and his monarchical power to further the Counter-Reformation in Austria and Bohemia. He surrounded himself with spaniolised advisers and allied himself with the Catholic party in Poland. Because of this, some historians have seen him as the agent of Catholic reconquest who only failed, in the end, through weakness of will, the consequence of psychological instability: thus, they say, the torch of the Counter-Reformation, which he had willingly taken up, slipped through his wayward and enfeebled hands.[3]

On the other hand, Rudolf soon showed that he was neither wholly Spanish nor wholly Catholic. Like his father, he distrusted, if he did not hate, his Spanish uncle, and he opposed Spanish policy in Europe, especially in the Netherlands: for the Spanish war in the Netherlands inevitably had inconvenient repercussions in western Germany. Nor did he approve of Spanish or Roman intolerance. Refugees from the Netherlands were welcomed at his court; many of his artists, scientists and friends were Protestants; and in his last years his closest friend and confidant, the president of his Imperial Privy Council, was the learned Protestant prince and fellow-patron of art and science, literature, alchemy and magic, Heinrich-Julius, duke of Brunswick-Wolfenbüttel.

Rudolf's attitude to religion, like that of Philip II, was shown by his choice of residence. Like Philip, he began his reign by moving his capital. His grandfather had established his capital in Vienna, and his father had kept it there; but Rudolf removed it, for his whole reign. Like Philip, he immured himself in a castle that was at once a fortress, a palace and a cathedral, and became increasingly inaccessible in it, increasingly involved in his private, spiritual world. Like Philip, he filled this palace with the art of his choice, the art that mirrored his own mind. But Rudolf's chosen capital was not new, like Madrid, and his chosen palace was not a defiant new structure, the architectural expression of a clear, rational, systematic orthodoxy. He preferred to live in an old city and an old palace: a centre of old heterodoxy, of the one medieval heresy which had triumphed over Rome.

Rudolf's chosen capital was Prague, the old capital of his kingdom of Bohemia. In the early fifteenth century Bohemia had been a great cultural centre, an advanced post of European humanism. But it had also been a centre of heresy: the heresy of John Hus. That heresy had led to fierce civil wars, but in the end it had established itself so firmly that the pope had been forced to recognise it, only showing his displeasure by keeping the Catholic archbishopric of Prague vacant for more than a century. Since those Hussite wars, Bohemia had been isolated in Europe, a backwater in Renaissance Christendom. By moving his court to it, Rudolf restored it to its old position as a cosmopolitan cultural centre; but it was a centre which still looked back to its humanist, heretical past. The castle in which Rudolf established himself was the old citadel, the Hradschin, which dominates the busy city all around it: it is very different from the Escorial, cold and lonely in the silent sierra. It too, by its timelessness, its periodical architectural accretions, illustrated the continuity of the tradition in which Rudolf placed himself, in contrast with the abrupt breach with the past marked by Philip II's stylistic repudiation. In this way Rudolf emphatically ignored the ideological polarisation which had been caused in the west by the events of the 1550s, and which was now being sharpened by the civil wars in France and the Netherlands. In the ancient, heretical city of Prague, and in its ancient historic citadel, he identified himself with a continuously evolving tradition and dissociated himself equally from the two radical innovations which challenged it: the militant Calvinism which was penetrating the Empire from the west, from Geneva and Heidelberg, and the militant Counter-Reformation which the Jesuits were carrying up from the south, over the Alps from Italy, and which was being pushed forward, by the invincible Spanish *tercios* from the Netherlands, on the lower Rhine.

If we look past the narrow retrospective definitions of politics and religious doctrine, if we follow Mr Evans and try to see Rudolf's intellectual world as a whole, in its own right and its own context, we shall, I believe, see something of the meaning, character and purpose of his patronage of the arts, and see it, perhaps, more truly than those who, by ignoring that context, and by approaching his collector's mania from the outside, or within the enclosed category of pure art history and art-criticism, have supposed that he was a mere eccentric, or a mere aesthete, pursuing art for art's sake: the first collector who 'freed himself entirely from every non-artistic criterion'.[4]

What was the world of Rudolf II? It was neither Catholic nor Protestant. Indeed, it was not religious at all. In an age of sectarian strife, of fierce religious antithesis throughout Europe, his court stands out, like that of queen Elizabeth in England, by its positive, almost aggressive religious indifference. In it we see the secular humanism of the high Renaissance carried forward, unbroken but developed, into the later sixteenth century. Universal in its claims, indeed more universal than ever, far wider and deeper than the merely classical humanism of the fifteenth century, with its blind

worship of the forms of antiquity, it is, at the same time, partly because it was both wider and deeper, partly because of the threat from without, tinged with pessimism, fretted with philosophic doubt. Above all, it was a magical world, a world of neo-Platonist 'natural' magic, whose philosophers looked beyond the multitudinous visible phenomena of nature and found a vast system of divinely ordered harmony, discoverable by research, intelligible by human reason, operable by the adept, the *magus*. This magical world repudiated the formal cosmology of medieval Christendom, and transcended the sectarian differences between orthodox Catholicism and orthodox Protestantism, both of which had returned to that cosmology. At its core, it was ecumenical, tolerant, contemplative, scientific; at its periphery, it ran out into alchemical fantasies, astrological calculations, Pythagorean numerology.

All these interests were represented at the court, and in the patronage, of Rudolf II, as indeed they had been at that of his father. They were also represented at other German courts. Nearly always these were Protestant courts: for although such views were accepted and expressed by Catholics –

View of Prague in Rudolf's day, showing the citadel, the Hradschin, and its cathedral at the top of the hill, *c.* 1060; engraving by Aegidius Sadeler (1570–1629).

by Francesco Patrizi, whose works el Greco read, by Tommaso Campanella, by Giordano Bruno – these Catholics were generally, in the end, rejected by their church: Patrizi was excommunicated, Campanella imprisoned, Bruno burnt. It was in the more tolerant Protestant courts, under learned and eccentric princes – in the Palatinate, in Württemberg, in Brunswick-Wolfenbüttel, in Hessen – that they throve. But the centre to which all these Protestant courts looked was the Imperial court of Rudolf II, nominally Catholic, in fact ambiguous, ecumenical and tolerant. Thither naturalists, astronomers, artists, scholars, adventurers, charlatans, converged from all Europe, some of them fleeing from Catholic persecution in the Netherlands, Italy or Styria (where Rudolf's nephew Ferdinand suffered no such nonsense),

Wenceslas Hall in the Hradschin, 1607; engraving by Aegidius Sadeler.

some drawn from Protestant countries by the temptations of Imperial patronage. So the most famous of contemporary astronomers, the Danish Tycho Brahé and the German Johannes Kepler, the most famous of mathematical and philosophical 'magi', the Englishman John Dee and the Italian Giordano Bruno, the most famous of alchemists, the Pole Michael Sendivogius and the Saxon Oswald Croll, the most famous of botanists, the Belgian Charles de l'Ecluse, and many other such men, all found themselves, at one time or another, in Imperial Prague which enjoyed, under Rudolf, a golden age of tolerance, patronage and unrestrained research.

Catholic and Protestant united to admire this tolerance, and were afterwards grateful to Rudolf for it. 'He has never been vindictive against the bodies, the souls, or the minds of his subjects: he is truthful and keeps his word', wrote one of his Lutheran subjects; and a bigoted Catholic, one of those who in 1618, after Rudolf's death, would be 'defenestrated' – i.e. thrown out of the window of the Hradschin in the Protestant revolt against the Habsburgs – would afterwards write that, 'while he ruled, the inhabitants of this kingdom were for many years not hindered at all in their various religious deviations; each man thought and believed whatever suited him best.' Even the Jews, so persecuted in Germany at that time, were not hindered in Bohemia, for the Jewish Kabbalah was part of Renaissance magic, incorporated into the great omnium gatherum of Hermetic Platonism. The oldest synagogue in Europe was in the tolerant city of Prague, and Rudolf himself (we are told) enjoyed long and secret conversations with the fabulously learned rabbi of Prague, Judah Loew.[5]

Thus if Philip II, in the Escorial, was the patron of unyielding Catholicism throughout Europe, Rudolf II, in the Hradschin, can be seen as the patron of that secular, ecumenical world of Renaissance humanism which still resisted both Reformation and Counter-Reformation, and which, with the passage of time, had become impregnated with magic and tinged with melancholy. Naturally the art which these two Habsburg monarchs patronised was different, even antithetical. While Philip demanded of his artists the reaffirmation of Catholic truth, of which he was the unquestioned champion, and required it to be expressed, anachronistically perhaps, but firmly, in the heroic forms of the high Renaissance, Rudolf, by necessity as well as choice, turned his back on the imagery of religious orthodoxy and claimed for himself another title. By his patronage he would show that he was not the head of a party in the Church, but the authentic, historic leader of the house of Habsburg, the champion of fragile Christian unity, against its external enemy, the infidel Turk, and, in the world of ideas, the patron of ecumenical humanism, strengthened, or at least transformed, by Platonic ideas of nature. Walking alone in his silent art-gallery, or in his private laboratory, he could see himself both as Roman Emperor, the incarnation of the Habsburg myth, and as the high priest of the new natural revelation, the crowned exponent of its emblematic, hieroglyphical, secret symbolism.

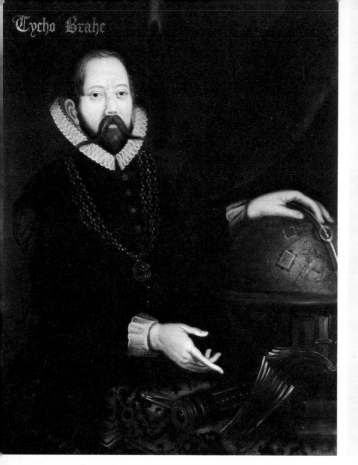

Tycho Brahé

ASTRONOMIA NOVA
ΑΙΤΙΟΛΟΓΗΤΟΣ,
SEV
PHYSICA COELESTIS,
tradita commentariis
DE MOTIBVS STELLÆ
MARTIS,
Ex observationibus G. V.
TYCHONIS BRAHE:

Juſſu & ſumptibus
RVDOLPHI II.
ROMANORVM
IMPERATORIS &c:

Plurium annorum pertinaci ſtudio
elaborata Pragæ,
A S. C. M. S. Mathematico
JOANNE KEPLERO,

Cum ejuſdem C. M. privilegio ſpeciali
ANNO æræ Dionyſianæ cIɔ Iɔc IX.

Tycho Brahé (1546–1601), the great Danish
astronomer who worked in Prague under Rudolf's
patronage; portrait by Michiel Mierevelt (1567–1614).

(Above right) Title-page of Johannes Kepler's
Astronomia Nova, commentaries on the orbit of the
planet Mars, published in Prague in 1609 with a
dedication to the Emperor. Kepler became Imperial
mathematician upon Brahé's death.

Title-page from Kepler's *Tabulae Rudolphi
Astronomicae* (Ulm 1627).

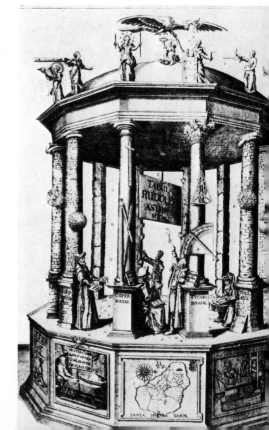

'Nova Orbis Terrarum Delineatio', world map by Philip Eckebrecht of Nuremberg, 1630, after Johannes Kepler.

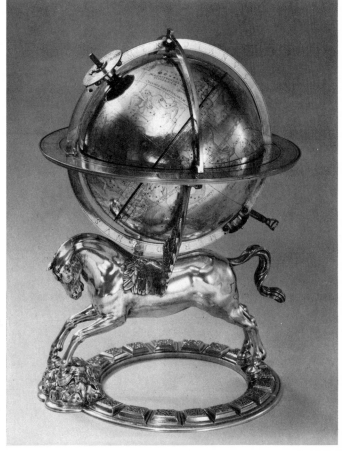

An astronomical globe, on the back of Pegasus, made in Vienna in 1579 by Gerhard Emmoser. This celestial sphere, which was rotated by a clockwork mechanism, appears in Rudolf's inventories, and was later in the possession of queen Christina of Sweden.

103

In this spirit the Emperor collected both old masters and new. The new were often inherited from his father: the 'Rudolfine age' really goes back before Rudolf just as it also runs on, for a few years after him, through the reign of his brother Matthias, until the delicate compromise collapsed in revolution and war. Like his father Maximilian, Rudolf pressed commissions on Giovanni Bologna, whom he would gladly have lured from Florence, and who, even from Florence, was to dominate the plastic art of Rudolfine Prague. He continued to patronise the bizarre surrealist Arcimboldo. Arcimboldo became his favourite, with access to him at all times, and acted as his agent in the hunt for pictures, jewels, curios. Bartholomäus Spranger and Hans Mont, the two artists whom the death of Maximilian had left stranded in Vienna, were not long without employment. They too were gradually drawn to Prague. We know little of Mont's work as a sculptor, though a typically Rudolfine – that is, an elegantly lubricious – statue of Mars and Venus had been ascribed to him.[6] He had to give up sculpture after an unfortunate accident: while watching a tennis match, he was hit by a stray ball and lost an eye. After this he returned to Italy and changed his profession. But Spranger became Rudolf's court-artist: he designed triumphal arches for the Emperor's entry into Vienna in 1577; he decorated the Hofburg at Vienna as well as the Hradschin in Prague; and in Prague the Emperor gave him a room next to his own so that he could watch him at work: for the royal patrons of the sixteenth century involved themselves in the work of their artists, and Rudolf (we are told) was an artist himself. He also found a rich wife for Spranger. Spranger's house became an artists' centre, and the best engraver in the Empire, Aegidius Sadeler, lived conveniently on the premises, to print and publish his work.

Meanwhile the Imperial talent-scouts were continually discovering new artists and bringing them, one after another, to Prague. The most famous of them was Adriaan de Vries, a Dutch sculptor, a worthy pupil of Giovanni Bologna, whom Spranger fetched from Augsburg, and who collaborated with him in several joint undertakings. Spranger designed the works of art which de Vries then transformed into statues and reliefs. Another was Hans von Aachen from Cologne, who recommended himself to the Emperor by sending him, from Florence, a portrait of the personally unattainable Giovanni Bologna. Von Aachen was similarly lured from Augsburg to Prague, where he became official portraitist of the Emperor, and was sent abroad to paint the succession of ladies whom the Emperor, for diplomatic purposes, pretended to be courting. Like Spranger, he too collaborated with the sculptor de Vries, and he too became a purchasing agent for the Emperor – in the end he would be the most active and trusted of all his agents in the great and quickening pursuit of artistic treasures. Rudolf also made great efforts to draw Federigo Zuccaro to his court: indeed, he was as eager to attract this high priest of academic mannerism to Prague as Philip II was to get rid of him from Madrid. Academic mannerism – serpentine movement,

Bartholomäus Spranger
(1546–1611), drawing
of Bellerophon.

Hans van Aachen
(1552–1615), *The
Liberation of Hungary.*

suggestive gestures, fluidity, mobility, graceful effeminate *maniera* – was the hallmark of that ambiguous court which disdained the rival heroisms, the granitic obstinacy and loud dogmatism of Reformation and Counter-Reformation, and looked back rather to the grace and sweetness of Parma – of Correggio and Parmigianino – than to the colour and *panache* of Venice or the strength and dignity of Rome.

Finally, there were the new landscape painters, whom the Emperor attracted from the Netherlands. These were mainly disciples of Pieter Brueghel the Elder – an artist whose work the Emperor particularly admired. Among them was Georg Hoefnagel of Antwerp, the illustrator of the towns of Europe,[7] who was in the Emperor's service from 1591. There was Pieter Stevens of Malines, who arrived about the same time and was made official court-painter in 1594: he specialised in pure landscapes, varied by fantastic buildings, jumbled ruins, obelisks and towers. There was the great nature-painter Jan Brueghel, 'Velvet Brueghel', who visited Prague in 1604 and received commissions from the Emperor. There was Paulus van Vianen, who came to Prague as goldsmith and stayed as landscape-painter. And there was Roelandt de Savery of Courtrai, the closest follower of Pieter Brueghel, who also arrived in Prague in 1604 and would become the first specialist

painter of Alpine scenery. The Imperial naturalist loved the crowded and
bizarre detail of these miniaturists of nature. He sent Stevens and Savery out
on special expeditions to depict the natural physiognomy of his empire, the
one to Bohemia, the other to the Tyrol. In the paintings which they brought
back with them he could enjoy the wild rural counterpart to the orderly
urban drawings of Hoefnagel.

These court-painters and court-sculptors, together with goldsmiths,
numismatists, glassmakers, engravers, and artistic technicians of all kinds,
formed a kind of inner court round the Emperor. Rudolf ennobled most of
them: he even gave a title of nobility to Giovanni Bologna, who never
himself came to Prague. He ennobled their art too: in 1595 he issued a
'Letter of Majesty' formally ordering that painting be henceforth described
not as a trade but as an art, and setting it free from guild rules. Through
these artists, he directed a veritable art-factory attached to his court. This
art-factory of the Hradschin, like the art-directorate of the Escorial, had of
course an ulterior purpose. But the purpose was very different. It had nothing
to do with religion. It is almost ostentatiously unreligious. The purpose is
twofold: the glorification of the house of Habsburg and the elucidation of
the mysteries of nature.[8]

107

Much of Rudolf's collection, both old and new, was designed to serve as propaganda for the house of Habsburg. He saw his great collection as a monument of his dynasty and was eager not only to keep it intact but to draw into it the collections of his kinsmen – particularly the great collection of his uncle the archduke Ferdinand of Tyrol who had filled his fabulous castle of Ambras with the treasures of art. Within the dynasty, Rudolf looked back especially to Maximilian I, whom he revered as his archetype, the founder of the family myth. Rudolf had a new crown made for himself, based on the *Ehrenpforte* which had been designed for Maximilian by Dürer. He also sought out the works of Dürer, wherever they could be found, no doubt partly because of Dürer's connection with Maximilian. After Maximilian, he revered his great-uncle Charles V (who was also, through his mother, his grandfather). He shared some of Charles V's tastes: clocks, clockwork, music – and the same kind of music too: elaborate polyphony, not the austere plainsong demanded by Philip II. At one time he too, like Charles V, contemplated abdication – but not to a monastery. Rudolf had no interest in monasteries or churches – unlike Catholic contemporary princes, he built none; art and nature were his religion, and his plan was to retire to his uncle Ferdinand's fairy palace at Ambras. There he could have refreshed himself not with tedious religious observances but by the contemplation of a *Kunstkammer* second only to his own. At the same time he acquired Leone Leoni's bronze bust of Charles V and commissioned Adriaan de Vries to make a companion bust of himself; and of course he collected, whenever he could, the works of Charles V's great painter Titian.

To collect Dürers and Titians required constant vigilance and prompt action in the art-market: for whereas new masters could be patronised and commissioned, old masters had to be prised out of galleries or churches. Rudolf II is perhaps the first collector who systematically sought to collect old masters by managing, indeed coercing, the market. He had his agents everywhere. Sometimes he used ambassadors: his ambassador in Spain, Franz Christoph Khevenhüller, was regularly employed for such purposes. He exerted his Imperial authority to make the lesser princes of Germany work for him: Heinrich-Julius, duke of Brunswick-Wolfenbüttel, for instance, or count Simon of Lippe. Italian princes too were pressed into service: the duke of Ferrara, for instance, whose father, having been Titian's patron, had left him a valuable artistic inheritance. The Emperor relied much on his own court-painters, especially Arcimboldo, Spranger, de Vries and von Aachen, and on other painters too, like the Milanese Paolo Lomazzo, 'il Brutto', who had made a fine collection of paintings, drawings and writings of his master Leonardo and profitably passed them on to the Emperor.[9] He also used his antiquary-royal, Jacopo Strada, a distinguished polymath who had been painted by Titian and who had a special relationship with the Emperor: for his daughter was the Emperor's mistress. On one occasion, he even used a wandering Jew called Seligman, to whom he

advanced money to buy *objets d'art* in Venice. But this proved a mistake: the Jew took the money and disappeared.[10]

Thanks to this army of agents and informers, Rudolf was informed of every opportunity. He knew where the most desirable old masters were hung and what pressure, or what event, would detach them. While other princes enriched churches, he did not hesitate to denude them of coveted altarpieces. And even if some great works seemed firmly held by jealous rivals, he would watch and wait: for while there was death, there was hope.

Rudolf's official correspondence with his ambassadors and with the princes of Germany shows him continuously alert for such opportunities. When a prince seeks a favour, the Emperor sends an agent to choose some trifle 'with which you can gratify us', or the prince is told of some desirable altarpiece which he might easily remove from a particular church in his

Among the many
precious objects made
for Rudolf were this
agate drinking cup,
ornamented with four
mermaids in gold
(above), which appears
in the inventory of the
Kunstkammer (1606/11),
and a bust of a young
girl carved from a gem
by Ottavio Miseroni, a
Florentine jeweller who
died in Prague in 1624.

A ship-clock of copper
gilt made for Rudolf II
c. 1580, with details of
the mechanism and the
Habsburg arms.

dominions. Reluctantly, the princes submit and send their treasures 'not counting the value of the thing', as one of them wrote, 'but to be received into your imperial favour'. So pictures, mirrors, jewellery, coins, sculptures, clocks, machines for perpetual motion, rare manuscripts, flow regularly into the Hradschin. Sometimes there are unexpected strokes of luck. Thus in 1602 the Emperor learned that count Eberhard zu Solm, coming to wait on him on behalf of the elector of Cologne, had died suddenly *en route*. He wasted no time in commiseration but wrote at once to the elector, saying that the count was thought to possess some very interesting works of art and alchemical and mechanical 'inventions', which the Emperor would be glad to receive, as a token of the elector's goodwill, as well as the French alchemist who had been employed in the count's household and who could now continue his experiments in the more famous and splendid laboratory of the Hradschin.

One of the greatest of such opportunities came after the death of cardinal Granvelle. Granvelle had been the dominating Imperial statesman of the whole century. He had been at the centre of affairs for fifty years. He was cosmopolitan in his experience and magnificent in his tastes. He was the greatest private collector of his time, the friend and patron of Titian and Leoni and many other artists. He had managed the artistic affairs of Charles V and Philip II. After his death in 1586, his collection passed to his nephew François de Granvelle, comte de Chantecroy, who shared his artistic tastes. But François de Granvelle was no match for the Emperor, who soon began to express his interest in the cardinal's collection. In 1597 the Emperor's researches were complete and he sent a list of the thirty-three works of art which he wanted, named his price, and then despatched his painter, the inevitable Hans von Aachen, and his jeweller, Mathis Krätzschen, to the Palais Granvelle at Besançon to collect the spoils. The unfortunate owner protested that the price offered was far too little even for six of such works – for Dürer's *Martyrdom of the Ten Thousand* he had recently refused, from cardinal Farnese, as much as the Emperor was offering for the whole lot. He was particularly reluctant to part with the Dürer, and sought – vain hope – to satisfy the Emperor with a copy of it. But of course it would not do. So, in the end, Granvelle yielded, preferring to satisfy 'the wish and pleasure of Your Majesty rather than my own private interest', and the Emperor gathered in his harvest. It included, besides the Dürer, Leone Leoni's bust of Charles V and many other works that recalled him: part of the tapestry of the conquest of Tunis, Titian's *Venus with the Organ-Player*, and a Virgin and Child 'which the Emperor Charles V kept by his bed'. There was also a tapestry by Hieronymus Bosch and Giovanni Bologna's copy of the ancient equestrian statue of Marcus Aurelius, the model for so many equestrian portraits of the time.[11]

Meanwhile another death had provided another opportunity. In 1598 Philip II died in Spain. As soon as the news was brought to Prague, the

Emperor wrote to his ambassador in Madrid, urging him to use all possible industry to secure some of the late king's best pictures, especially by Titian, Bosch and Parmigianino; and he reminded him that the king's fallen secretary, António Pérez, once so powerful, now an exile abroad, had made a fine collection, most of which the king had secured at his fall. Now was the time to secure some of those works too, in particular certain works of Correggio and Parmigianino, known to have passed into the king's hands . . . The ambassador moved in, but he was not quite quick enough. He was outwitted by a resourceful private speculator, our old friend Pompeio Leoni. Leoni knew what he was doing: he bought what the Emperor most wanted and then sold it to him making a quick profit for himself.[12]

In every direction, Rudolf used all the techniques of the powerful collector. Through von Aachen he managed to get Dürer's *Adoration of the Magi* from the elector of Saxony. He sent von Aachen to the Netherlands to collect the works of Lucas van Leyden. He particularly wanted Lucas van Leyden's *Last Judgment*, from a church in Leiden. Prince Maurice, the stadhouder of the Netherlands, was willing to help, but the living artists of the Netherlands rebelled. Hendrik Goltzius and Karel van Mander protested to the city council of Leiden, and the city refused to part with the picture. The artists of the Netherlands were conscious of their national losses. Habsburg greed and Protestant violence had drained away or destroyed too much of their artistic inheritance, and they fought to preserve what remained.

The Emperor was more successful in his quest for the works of Dürer. Here nothing, it seemed, would stop him.[13] The whole machinery of persuasion was mounted, and directed especially at the Imperial cities of Augsburg – Dürer's own city – and Nuremberg, which had several desirable works of the master. Another Imperial city, Frankfurt-am-Main, held out: not even for 10,000 gulden could the Emperor detach Dürer's *Assumption* from the Dominican church there – although after Rudolf's death, his nephew Maximilian, duke of Bavaria, contrived to obtain it 'by extraordinary exertions and expense'.[14] However, Rudolf compensated for this failure by a great scoop in Italy. There, in 1606, he acquired Dürer's *Feast of the Rose Garlands*, a painting full of Habsburg symbolism. So precious was this acquisition that he would not trust it to a carriage, but had it carefully wrapped in carpets and transported across the Alps from Venice by relays of strong men to hold it upright and unharmed. We are reminded of the *cortège* which carried Benvenuto Cellini's *Crucifixion* to the Escorial for Philip II. But this time the work was more highly appreciated and was given a place of honour in the Imperial collection.

If Rudolf saw himself as the heir to Maximilian and Charles V in their patronage and public imagery, it was necessary also to imitate some of their achievements. Maximilian had dreamed of a crusade against Islam, and Charles V thought, for a time, that he had realised it in his capture of Tunis. It was mortifying to Rudolf that his hated uncle Philip II should be able to

Albert Dürer, *Feast of the Rose Garlands*, 1506. Painted originally for the German church of St Bartholomew in Venice, this masterpiece was acquired by Rudolf II in 1606. The figure kneeling at the Virgin's left is the Emperor Maximilian I, Dürer's patron.

boast of the victory of Lepanto while he himself had achieved nothing. However, in 1593 the peace with the Turks was at last broken. The long war which followed was not spectacular or decisive, but it began with an Imperial success at Sissegg and it ended, after thirteen years, in an Imperial advantage: at least the Emperor was now recognised as an equal by the sultan and did not have to pay an annual tribute as king of Hungary. Rudolf was pleased to advertise these successes and present himself too as a Christian crusader. Just as Charles V had taken Vermeyen with him to Tunis, to record his victories, so Rudolf mobilised the Spranger-de Vries partnership, and in their allegorical paintings, reliefs, statuary, the Emperor appeared not only as Augustus and Imperator but also – not perhaps very convincingly – as the favoured *protégé* of Bellona, goddess of war, the conqueror of the Turks, the liberator of Hungary, the mediator of Europe. And just as Charles V had had Vermeyen's war-paintings reproduced as tapestries by the weavers of Brussels, so Rudolf sought to have his 'greatest victories' depicted in the finest Netherlands tapestries, incorporating designs of his own invention.[15]

In these paintings and reliefs Rudolf also had himself presented, by elaborate symbolism, as the patron of the Muses, the adept of the occult sciences, the investigator of nature. Arcimboldo had painted a composite head of the Emperor as Vertumnus, the Roman god of the changing seasons, made out of vegetables, flowers and fruit; Spranger and de Vries showed him bringing the liberal and plastic arts to Bohemia; and his landscape-painters specialised in the representation of 'animated nature'. Hoefnagel painted plants and animals as hieroglyphs of nature and presented Rudolf with a whole panorama of the animal kingdom in four quarto volumes; and Roelandt de Savery dotted his biblical or rural canvases with exotic animals and birds, including the first portrait of the recently discovered dodo which he may have seen in Rudolf's menagerie.[16] In this one respect perhaps we can see a parallel between Rudolf and his uncle Philip II. Both loved nature, and detail. Philip sponsored a great compilation of the natural history of Spain and America; he loved to contemplate plants and birds and was haunted by the song of nightingales. His passion for detail is famous. But in the world of art, the detail in which these two Habsburg princes delighted was somewhat different. If Philip II loved the bizarre theological detail of Hieronymus Bosch, Rudolf preferred the more earthy detail of Pieter Brueghel the Elder. He particularly collected the works of Brueghel: there were at least ten of them in his collection, including the famous *Dulle Griet*, the *Witch Scene*, and *The Land of Cokayne*. He also, unlike the cold, chaste Philip, enjoyed the erotic suggestiveness of mannerist art. Indeed, in the work of his painters, this characteristic becomes ultimately oppressive: as we look at the series of mythological and allegorical works executed for

Bartholomäus Spranger, *Salmacis and Herma-phrodite*, one of a series of five Metamorphoses.

him by Giovanni Bologna and Spranger and de Vries – all those rapes of Sabine women, or of Europa, those abductions of Psyche, or Ganymede, or nymphs, by Mercury, or fauns or satyrs or gods or centaurs, those elderly

Details from Pieter Brueghel's
Dulle Griet and
(opposite) *The Land of Cokayne*.

Sileni ogling or pinching or stroking naked and plump-bottomed ladies,
we begin to realise that this eccentric elderly bachelor had certain special
interests. Certainly he did not accept the new prudery of the Counter-
Reformation.

In his last years, Rudolf II's gallery was famous throughout Europe, and

artists and connoisseurs vied for the privilege of seeing it. 'Nowadays, whoever so desires', wrote the Dutchman Karel van Mander, 'has only to go, if he can, to Prague, to the greatest art-patron of the modern world, the Roman Emperor Rudolf II. There, at the Imperial residence, as elsewhere in the collections of other great art-lovers' – for of course the Imperial example was copied by the Bohemian nobility, the Rožmberks and Lobkowiczs and Liechtensteins – 'he can see an extraordinary number of outstandingly rich, curious, strange and priceless works.' Perhaps we should italicise the adjectives 'curious' and 'strange': that was one particular characteristic of Rudolf's collection. Perhaps we should also italicise another limiting phrase: 'if he can'. Not everyone could go to Prague and fewer still could obtain access to that jealously guarded picture-gallery. But of course a visiting artist or art-historian like Karel van Mander would have no difficulty.

But even if a man could penetrate the gallery, would he see its imperial owner? That was less certain. The Emperor by now had become a legend, a living legend. The legend was launched, in 1607, by the Scottish Catholic émigré John Barclay, in his *Satyricon*, a once famous *roman à clef* in the style of Petronius. Here he described an imaginary visit to the court of Aquilius, king of the Thebans, whom readers easily recognised as Rudolf, Emperor of the Germans. Barclay was taken there, he pretends, by George, landgrave of Leuchtenberg, the Emperor's high steward. Aquilius, he found, lived a secret life of 'voluntary solitude' in his hushed palace; his courtiers waited vainly outside while he was mysteriously closeted with painters and scientists. In his private apartments he was surrounded by statues and pictures illustrating not wars and heroes but seductive, not to say shameless, women of exaggerated beauty and unnatural grace – we recognise the mannerist style – the ideal models of the ladies who were then to be sought out for his pleasure. On the table before him stood two globes, terrestrial and celestial, and dog-eared astrological books, with whose aid he defied divine jealousy and penetrated the darkest secrets of nature, seeking to extract the souls of metals, and to distil the elixir of life. Hard at hand, in his laboratory, his chemical workers were busy with burners, crucibles and retorts, under the direction of a white-robed figure who would come furtively but freely to his master, bringing the precious extract. '"Who is this man, who is honoured with such familiarity?" I asked; and my guide replied, "he is the most favoured person in the whole palace: a Jew."'[17]

Such was the legend of Rudolf in his last years. It was not far from the reality. For with the passage of time his eccentricities had become more marked. In 1600 he went through a severe crisis of melancholy, due, it was said, to his long involvement in necromancy and alchemy, his hatred of the Church and his growing conviction that he was a damned soul. This, incidentally, was the time when the Catholic Church was persecuting the Hermetic philosophers, the magicians: it was in this very year that Giordano Bruno, whom Rudolf had patronised in Prague, was burned in Rome. In

desperate attempts to free himself from the Spanish and Catholic party at court, Rudolf lashed out in all directions, dismissing, insulting and imprisoning his ministers. He spoke again of abdication and apparently attempted suicide. For two years it was actually thought that he was dead. But he was not dead: it was merely one of his periodical vanishing tricks. He had disappeared from view into the recesses of his palace where he was communing only with 'underlings' – that is, with his servants and confidants – 'wizards, alchemists and kabbalists', as his indignant family complained – court-painters and court-naturalists. With them he contemplated his jealously reserved picture-gallery, which few outsiders were allowed to see, or conducted strange experiments in search of the philosopher's stone. His family declared that he had renounced God and was preparing to worship the Devil.

Certainly, he had renounced real worldly power. By 1609, when he was designing and ordering tapestries to commemorate his great victories, and when James I of England, that other erudite monarch, was dedicating to him,

as the greatest prince of Christendom, his defence of lay monarchy against the claims of the pope, the Emperor (as a despairing Tuscan diplomat wrote) was politically impotent, having ruined all by his excessive zeal in the study of art and nature. He had deserted affairs of state for alchemists' laboratories, painters' studios, and the workshops of clockmakers. He had given over his whole palace to such researches, diverted all his revenues to them, estranged himself completely from humanity, become a solitary hermit, and left Church and Empire to go to ruin while he 'shut himself off in his palace as if behind the bars of a prison'. Two years later the final revolt began. His outraged family resorted to arms; the Emperor was deposed from his kingdom in Bohemia; and his next brother Matthias was elected to his throne. Ten months later, Rudolf was dead.

It had been Rudolf's hope that the fabulous collection of old and new masters which he so personally built up, for his own private, secret contemplation, should become a permanent imperial collection, part of the glory of his

Roelandt de Savery,
Landscape with Animals
(detail).

123

dynasty. In this, as in so many of his hopes, he was disappointed. Seven years after his death, the revolutionary Calvinists in Prague, having momentarily deposed the Habsburg dynasty from the throne of Bohemia, demanded the sale of these shameless naked figures, so offensive in a godly state. Then, with the Catholic reconquest, a different kind of art came into Bohemia: not secular, mythological, emblematic of natural philosophy and mannerist virtuosity, but religious, Catholic, dogmatic. As a Czech writer puts it, 'The olympian gods, the Graces, Muses and Nymphs wander into exile and in their stead come new and foreign guests: all those Spanish and other saints with grim, ascetic features'.[18] The spirit of Philip II had prevailed over the spirit of Rudolf II.

Finally, in 1648, came the great disaster. After thirty years of war, on the very eve of peace, the Swedish army of count Königsmarck stormed and sacked the city of Prague. By that brutal and unnecessary act, the richest and most fantastic collection that Europe had known was pillaged and scattered. The bulk of it was sent off to Sweden to fill the castles of Königsmarck and Wrangel and gratify the vulturine queen.

So Dürer's marvellous *Adam and Eve* and hundreds of other European masterpieces were carried off to the royal palace of Stockholm before being redistributed piecemeal to Spain, France, England; the bronze busts of Leoni and de Vries decorated the Swedish castle of the Königsmarcks until they were ransomed by an Austrian ambassador 150 years later;[19] Giovanni Bologna's equestrian statue of Rudolf II is still in the National Museum in Stockholm; Hans Mont's lascivious *Mars and Venus* adorns the Swedish royal palace of Drottningholm; and most of the surviving 'composite heads' of Arcimboldo are still today in Swedish hands.

A bowl of bezoar made in the Imperial court workshop in Prague.

It has been said – rightly I believe – that a whole intellectual world, a whole philosophy, perished in the Thirty Years War. It would be rash to say precisely what destroyed that world: whether it crumbled from within or was shattered from without; whether it foundered in the suicidal wars of religion, or was trampled underfoot by the armies of Wallenstein and Gustavus Adolphus, or whether it dissolved upon contact with the mechanistic Reason of Descartes. But if the artistic embodiment of that philosphy is to be found, as I have suggested, in the art-gallery of Rudolf II, then we may say that the *coup de grâce* was given to it by that dreadful woman, the Cartesian princess, the crowned termagant and predatory bluestocking of the north, queen Christina of Sweden.

Bartholomäus Spranger, *Pallas protects the Arts and Sciences*, a painting which was in Rudolf II's collection.

However, when that happened, the Rudolfine era had long been closed, and in the intervening generation a new philosophy and a new art style, had been created, more coherent and more lasting than the mannerist grace of Giovanni Bologna or the surrealist eccentricities of Arcimboldo. It too had thriven under Habsburg patronage, indeed under the patronage of Rudolf's youngest brother, in the last of the four Habsburg courts: the new archducal court of Brussels.

CHAPTER 4

The Archdukes and Rubens

FROM MADRID, VIENNA, PRAGUE we return, in conclusion, to the original home of the northern Renaissance and of that Burgundian magnificence which had been taken over by the house of Habsburg: to the Netherlands, whose glory, in that century, seemed so sadly to have declined.

Cast an eye back to the Netherlands in 1520 when Charles V made his Joyous Entry into Antwerp. The Netherlands were then the eye of northern Europe. What had Spain or Austria or Bohemia to show compared with the paintings of van Eyck and Memling, Quentin Metsys and Hieronymus Bosch? Netherlands music had conquered Europe and was performed, by Netherlands artists, in the Vatican itself. Netherlands architecture had invaded Spain. Erasmus of Rotterdam was the intellectual leader of Europe. The court of Spain itself was a reflection of the Burgundian court: Charles V would reorganise it *a la borgoña*, make it more hierarchical, more magnificent. The grandest order of Spanish chivalry, the Order of the Golden Fleece, was imported from the Netherlands. And all this splendour rested on solid economic foundations. The industry and commerce of the Netherlands sustained not only the brilliant Burgundian court but the centre of international finance. Antwerp, in 1520, with its great merchant bankers who controlled the trade of Europe and the New World, was the economic capital of Europe.

Fifty years later, all this was sadly changed. By the departure of the royal court to Spain, the Netherlands had lost their sovereign and found themselves reduced from proud independence into an overseas province. Little by little, by mistake after mistake, Philip II had driven them to revolt. Political revolt had been turned into civil war, civil war into ideological war, fomented by outside powers. A once flourishing country had become a kind of European Vietnam in which the old unity had been painfully destroyed. Out of its wreckage, the polarisation of parties, persecution, emigration, and the pressures of war had created two new societies, ideologically opposed to each other: the independent Protestant north, dominated by the province of Holland and the new dynasty of the house of Orange, and the 'reconciled' – that is, the reconquered – south: Catholic Belgium, 'Flanders' as the Spaniards always called it, now entirely subject to Spain.

In the long story of the revolt of the Netherlands, certain episodes are of great significance for the history of art and art-patronage. The first was in 1566–67. In that year, a year of famine, Calvinist preachers directed the

Peter Paul Rubens (1577–1640), *The Horrors of War* (detail).

127

The destruction of statues and stained glass in a
church in the Netherlands during the iconoclast
riots; drawing by F. Hogenberg in Baron Michael
von Eytzinger's *De Leone Belgico*, 1583.

mutinous and starving urban poor against the 'images' in their midst. This
was an old radical gesture which the moderate Protestant reformers, includ-
ing Luther himself, had always opposed. But when Protestantism became
revolutionary, their opposition was in vain. In Germany and Switzerland in
the 1520s, in England and Scotland in the 1550s, the mobs had been incited
against the 'dead images' in the churches to whom 'the living images of
Christ', the poor, were sacrificed. And nowhere in northern Europe were
there so many 'dead images' to destroy as in the Netherlands. In 1566 the
iconoclastic riots began in Antwerp; then the epidemic rage spread to
Bruges, Middelburg, Ghent, Amsterdam, The Hague. The mobs broke
into the churches, defaced statues, destroyed pictures. And the process, once
begun, did not cease. Again and again, in moments of crisis, 'iconoclasm'
would break out: sometimes indiscriminate and violent, sometimes (as in
Antwerp in 1581, when the Calvinists took over the city) controlled and
regulated by astute Protestant politicians. When the work of destruction
was over, the bare walls of the churches would be whitewashed: the idolatry
had been purged away.

The artistic losses caused by these iconoclastic outbursts were great. At
's Hertogenbosch two paintings by Hieronymus Bosch were destroyed. In
Amsterdam, Utrecht and Gouda a series of works by Jan Scoreel were hacked
down and burned 'along with many other beautiful things, by the demented
plebeians'.[1] At Delft, Louvain and Diest, several works by Pieter Aertsen
were lost.[2] The Protestant Karel van Mander, the Vasari of the north,
lamented this 'tragic loss to art' caused by 'the vicious hands of raving,
insane iconoclasts'. At Antwerp in 1581, Quentin Metsys' famous triptych,
The Deposition, was ransomed by the citizens at the instance of the Lutheran
painter Martin de Vos. At Ghent, Frans Floris' *St Luke* had a narrow escape:
the painter's teacher, the Protestant artist Lucas de Heere, hid it in his work-
shop; and the great pride of early Netherlands painting, Jan van Eyck's
Adoration of the Mystic Lamb in the church of St Bavon, only survived after a
series of hairbreadth escapes. Thus if the Catholic party recovered control,
it found work to be done: statues, windows, altarpieces had to be replaced –
and replaced, if possible, more splendidly than ever, as a gesture of defiance,
to show that the Church was not defeated but grew stronger by persecution.

The burning of the Town Hall during the sack of Antwerp in 1576; from Eytzinger's *De Leone Belgico*.

Unfortunately, in those years, while Protestant intolerance had reduced the reserves of art, Catholic intolerance had reduced the supply of artists. Some of the Netherlands artists were Protestants – moderate Protestants who hated the fanatical iconoclasts; some were Catholics, but moderate Catholics who hated the Spanish terror and Inquisition. Like so many of the best spirits in the Netherlands, they were disciples of that greatest of Netherlanders, Erasmus. Consequently, in the years of war and persecution, they often left. Particularly they left when danger came to the economic and intellectual capital of the Netherlands, Antwerp.

For Antwerp was their metropolis. There was the organised art-market, there was the guild of painters, there were the technicians of their trade, there were the great printers who published engravings of their work. But from the middle of the sixteenth century the prosperity of Antwerp suffered a series of fearful blows. First there was the international depression and bankruptcies of the 1550s; then came the time of troubles, of political disturbance. In 1566 came the iconoclasts, and after them the terrible vengeance of the duke of Alba's Tribunal of Blood. In 1576 the city was sacked by the unpaid and mutinous Spanish army. In 1581, it was taken over by the Calvinists.

In 1585, after a long and terrible siege – the most famous siege in history, a Spanish writer called it – it was retaken by the Spaniards. When it had been retaken, all obstinate Protestants were expelled from it. Already there had been a great exodus from the city. Merchants, bankers, scholars – the men who had made the greatness of the city – Catholics and Protestants alike, had emigrated to Amsterdam, London, Cologne, Frankfurt, Wesel. Now the last of the great Protestant merchants left, and carried their skill and credit, and also their desire for revenge, to the new commercial capital of the northern Netherlands, Amsterdam. In one very material way they were able to gratify their spirit of revenge; for the Spaniards, who had retaken Antwerp, could never recover its outlet to the sea, the estuary of the Scheldt. This ran through the province of Zealand which, with Holland, formed the heart of the revolt. Naturally, the *émigrés* in Amsterdam exploited this advantage. By keeping the Scheldt firmly closed, they strangled the commerce of Antwerp and raised Amsterdam, from a fishing port, to be the new economic capital of Europe. Amsterdam rose on the ruin of Antwerp.

Among those who left Antwerp in those troubled years were the artists. Artists and craftsmen, we are told, were the largest class of *émigrés* after the merchants. Many of them, as we have seen, went to Prague or to Italy. Others went to the German Palatinate on the Rhine where the Calvinist elector built a special city of refuge for his co-religionists fleeing from France and Flanders. It was at this new city of Frankenthal that Protestant refugees from the Netherlands founded the Dutch school of landscape-painting.

But what of those men who did not, or could not, emigrate? In spite of its misfortunes, Belgium remained a financial and intellectual centre in Europe and many of its great merchants, scholars and artists refused to despair of the future. They still looked back to Erasmus and hoped, when settlement should return, for an Erasmian future. Meanwhile they conformed to the ruling orthodoxy. Among these outward conformists, who reserved to themselves an inner freedom, were some of the most liberal spirits in Europe. Christopher Plantin, the great printer, Abraham Ortelius, the great geographer, sat in Antwerp at the centre of a European Republic of Letters. Both were officially accredited by the court of Spain. Both were formally Catholics. Both, it seems, were secret heretics, members of the non-denominational sect, the Family of Love, which sought to continue the old Erasmian ideals in a new guise. Another ambiguous character who, in the 1590s, returned to his native Belgium, was the man whom contemporaries saw as the greatest philosopher of his time: Justus Lipsius.

It is difficult today to understand the reputation which Lipsius enjoyed in his own time. He was a classical scholar who edited Tacitus and Seneca, who changed his religion three times, and whose most famous work was entitled *Of Constancy*. Born a Catholic in Brabant, he went to Rome as secretary to cardinal Granvelle. On his way back he stopped for three years in the strict Lutheran University of Jena, where he became a Lutheran.

A sketch by Rubens of a printer's mark for the Plantin Press, 1627–28.

Afterwards he spent thirteen years as a Calvinist in Calvinist Leiden. Then he returned to Brabant and Catholicism, and spent his last years in Louvain as the tame scholar of the local Jesuits, giving his great authority to their most puerile miracles. In spite of these changes, he was constant in a sense: constant in the Erasmian humanism which he protected by superficial conformity with the dogmas of time and place. Lipsius' great fame in his own time, among Catholics and Protestants alike, can only be explained by the veneration of that age for classical scholarship and by the popularity of the new philosophy, of which he was the greatest advocate. This philosophy was neo-stoicism. Stoicism, the rational cult of virtue, undisturbed by passion or misfortune, appealed to a distraught society clinging to the tradition of a better time, and neo-stoicism, christianised stoicism, was a version ideally adapted to the Christian Netherlands. The great Roman stoics – Seneca, Lucan, Marcus Aurelius, the men who clung to ancient republican virtues in distracted imperial times – were the new lay saints of the seventeenth century. Above all Seneca. It was Lipsius who converted Seneca, the most famous of Roman stoic philosophers, into a Christian saint, especially for the harassed Netherlands.

A country ravaged by sectarian war and foreign armies, churches desolated by iconoclasm, a massive emigration of talent, and yet a conviction, among its best spirits, that all was not lost, that the old greatness could be restored, if only the spirit of man remained sound and the old ideals were not forgotten – such was the condition of the southern Netherlands, the heart of the old Burgundian civilisation, when Philip II died in 1598. Just before his death, the

132

Design by Rubens for the title-page of Justus Lipsius' *Opera Omnia* (Plantin Press).

old king performed a great act of apparent renunciation. Hitherto he had been a remorseless hard-liner, refusing anything less than unconditional surrender to Spain, and rejecting with contempt the successive compromises proposed by his less rigid Austrian kinsmen. Now, in his last months, he himself settled for a compromise. He had a favourite daughter, unmarried and unprovided. He had tried to conquer for her the crowns first of England, then of France, and her marriage, of course, was involved in these projects, which had failed. Now, on his deathbed, he arranged for her marriage to his nephew the archduke Albert, the youngest brother of the Emperor Rudolf, and he devolved upon the happy couple, in full sovereignty, for their joint lives, the government of the Netherlands: of all the Netherlands in theory, in fact of the 'reconciled' provinces, Belgium. The sovereignty, as it turned out, even over Belgium, was less than full; but we need not, for the moment, be concerned with that. For our purposes, for the next thirty-seven years, Belgium was ruled by 'The Archdukes' – that is, first, until 1621 when Albert died, by Albert and Isabella as 'independent' princes; thereafter by the widowed Isabella alone, as governor for her nephew, the king of Spain.

For the first eleven years of their rule, the archdukes were at war, as the Spanish armies continued the fight against the 'rebel' provinces in the north. But in 1609 the archduke, aided by the Genoese general in command of the Spanish army, Ambrogio Spinola, at last forced his will on the reluctant Spanish government, and a 'truce' of twelve years was arranged. In these twelve years of peace the archdukes, who identified themselves completely with their Belgian subjects and became genuinely loved by them as benevolent native rulers, set out with determination to repair the ravages of the last forty years: to restore prosperity, reclaim the exiles, rebuild the shattered towns, replenish the desolated churches. In order to do this they needed to evoke new, con-structive ideas. Those ideas could not spring from mere conservatism, the unyielding traditionalism of Philip II. They could not arise from such a continuation and refinement of humanism, oblivious of ideological war, as had survived in Rudolfine Prague and been expressed in Italian mannerism. They needed more than the non-denominational stoicism which had carried individual men unbroken through the years of misfortune. What was now required was something which, while using these ideas, would breathe into them a new spirit: a spirit not merely of antique virtue, new suppleness, passive fortitude, but of dynamism, confidence, even heroism: heroism in the preservation of old traditions, confidence in the assertion of their permanent vitality. This spirit was supplied, in art, by the genius of one man, Peter Paul Rubens.

Rubens' family came from Antwerp, but he himself was born and, for his first ten years, brought up in Cologne; for his father was a Protestant who had fled thither to escape from Alba's Tribunal of Blood. But in Cologne Jan Rubens evidently returned to Catholicism and his son was brought up as a Catholic, under the influence of the Jesuits. Returning to the Netherlands at

the age of ten, he lived for thirteen crucial years in a society devastated by war. In those years he became an accomplished humanist scholar, an admirer and connoisseur of Roman antiquity, a disciple of Lipsius. He also acquired a deep hatred of war, and especially ideological war, which never left him. Meanwhile he studied painting, under various masters, the last of whom was Otto van Veen.

Van Veen was a refugee from Holland, of noble though illegitimate birth, who had studied under the mannerist Federigo Zuccaro in Rome, and had been influenced by the great artists of Parma, so loved by Rudolf II: Correggio and Parmigianino. Of wide culture and patrician manners, he had been sought out by many royal patrons, including the Emperor; but he preferred to return to the Netherlands – but to the Catholic Netherlands – and become court-painter in Brussels, first to Alexander Farnese, duke of Parma, Philip II's governor-general, then to the archdukes. Like so many of the artists of that unspecialised time, he was an architect and engineer as well as a painter. It is possible that, through van Veen, Rubens was already known to the archdukes in 1600, and that it was they who recommended him, in that year, to the duke of Mantua. However that may be, at the age of twenty-three, Rubens went to Mantua. There he enjoyed (as he would afterwards write) 'a delightful residence' and 'never received anything but good' from the princely family of Gonzaga. It was an excellent apprenticeship, for the Gonzaga of Mantua were one of the greatest dynasties of art-patrons in Italy. They had been the patrons of Mantegna and Giulio Romano; it was they who had introduced Titian to Charles V; their gallery was one of the most famous in Europe. Afterwards, when a degenerate duke sold it to Charles I of England, Rubens would explode with disgust. He wished that the duke had died first; for with that great gallery the genius of the place, he felt, had departed.

While in the service of the duke of Mantua, Rubens was able to travel widely and, by travel, to study the great artists of the high Renaissance who still towered above their fashionable mannerist successors. In 1603 the duke sent him on a delicate mission to Spain, and there he saw the Titians collected by Charles V and Philip II, and painted an equestrian portrait and a series of religious pictures for the all-powerful favourite, the duke of Lerma. This combination of diplomacy and artistic experience was to become a recurrent feature of his life; but for the moment the artistic experience was to prevail. Though his public career was to be dominated by Spain, and he would afterwards revisit it, he disliked the cold severity of Spanish life, the religious bigotry of its learned men. Titian to him was of more value than the patronage of Lerma or Philip III, and he returned gladly to the gaiety and warmth of Italy.

In Italy he travelled too: to Genoa, to Venice, to Rome. He loved Genoa and lingered long in it. He always followed events in Genoa with interest. Afterwards he would write a book on the palaces of Genoa, and one of his

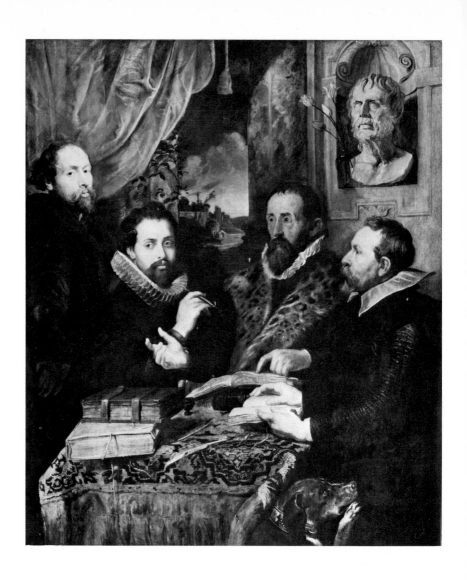

Rubens' portrait of
Justus Lipsius with
three disciples, including
the artist himself and his
brother.

great heroic cycles – the series of paintings of the Roman consul Decius Mus –
would be commissioned by Genoese patrons. But his greatest experience was
at Rome, where he joined his brother Philip. Like him, Philip was a lover of
antiquities and a disciple – evidently the favourite pupil – of Lipsius. A
German doctor who attended Rubens in 1606, the year of Lipsius' death,
declared that he and his brother were both worthy to succeed the great man in
his chair at Louvain. In Rome the two brothers studied antiquities together,
and Rubens afterwards painted himself, his brother and a friend, as three
disciples gathered round Lipsius under the bust of the stoic philosopher
Seneca. The bust was a Roman bust, of which he had himself acquired a
copy. From this bust, and from a well-known Roman statue, then thought to
portray the subject, Rubens painted his picture of the dying Seneca. He also

136

painted a memorial portrait of Lipsius to hang in the house of Lipsius' publishers, the Plantins.

Rubens, *The Death of Seneca.*

But if Rubens in Rome was the humanist scholar and stoic philosopher, he also discovered there a new ideal, very different from the patient patrician heroism which Lipsius had seen as the only means of preserving the spirit of Erasmus in a time of trouble. For it was in Rome that Rubens discovered the work of a new artistic genius who shattered all the conventions of his time. This was the stormy petrel who at this time was skimming the tempestuous waters of Italian art, Michelangelo da Caravaggio.

The disorderly strength, the fierce, unconsecrated, indecorous realism of Caravaggio divided his patrons, scandalised the Church, and infuriated the established art-critics. The Counter-Reformation Church required that its

137

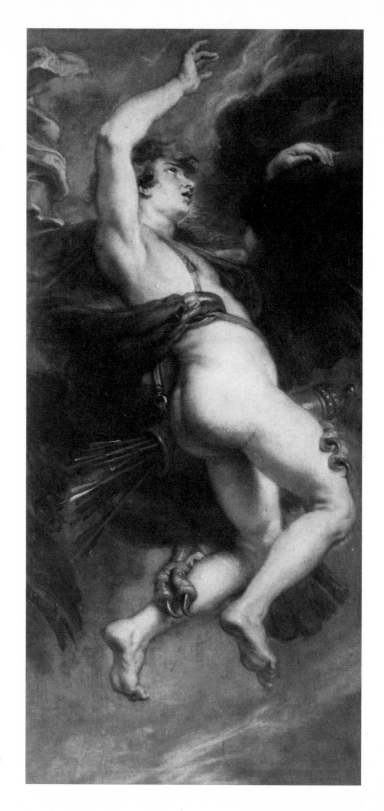

Rubens, *The Rape of
Ganymede*.

artists conform to exact rules: rules of doctrine, rules of propriety. The artistic establishment required that they conform to its academic conventions. The violent, outrageous life of Caravaggio, which burnt itself out at thirty-six, would have shocked Lipsius with his philosophy of outward conformity, inner harmony. But his work clearly excited Rubens. Here at last was a living alternative to the stylised, academic grace of mannerism. Rubens copied some of the works of Caravaggio in Italy. He persuaded the duke of Mantua to buy Caravaggio's controversial *Death of the Virgin*, as he would afterwards persuade his Belgian colleagues to buy Caravaggio's *Madonna del Rosario* for a church in Antwerp. His own work, in form so aristocratic, so majestic, so olympian, pulsates with a vigour which is often animal and crude. We think of his battle-scenes and his lion-hunts, or of those dreadful paintings of Saturn devouring his child, or Judith slicing off the head of Holofernes or centaurs on heat. His Bacchus, his Silenus, his rapes of Prosperine and Ganymede, are very different from the elegant postures and tentative seduc-tions which so pleased Rudolf II. In many of his works Caravaggio provides an explicit model. If we are to define Rubens' own great achievement, we can perhaps say that to the classical traditions of the high Renaissance and the aristocratic stoicism of a suffering society, he harnessed the new vitalising energy and realism of Caravaggio, and thus, incidentally, provided a new imaginative force to the European Counter-Reformation.

In his study of mannerism, Mr John Shearman writes that 'the recovery of organic energy' after the languid aestheticism of the later sixteenth century was the achievement of the generation of Caravaggio, Monteverdi and Rubens.[3] We may observe that the work of Monteverdi, as well as that of Caravaggio, must have been familiar to Rubens. Indeed, they must have known each other personally, for throughout the years of Rubens' appoint-ment at Mantua, Monteverdi was there as the duke's *maestro di capella*, and it was there, in 1607, that he produced his opera *Orfeo*. Afterwards Monteverdi would move to Venice; but his sympathy with Rubens would be shown in the last year of both their lives, when he produced his masterpiece *L'Incorona-zione di Poppea*, whose hero is Rubens' hero, Seneca.

When Monteverdi carried his gifts to Venice, Rubens had already carried his to his native Belgium. By a happy coincidence of circumstances, he returned to Antwerp precisely when he was most needed and precisely when his great opportunity was about to open. For late in 1608, when he was still in Italy, he heard that his mother was ill in Antwerp. He set out to Antwerp, but by the time he arrived there, his mother was already dead. He therefore prepared to return to Italy 'for ever'. He had been invited to Rome, he wrote, 'on the most favourable terms'. But at this point the archduke Albert stepped in. He pressed Rubens to enter his service, using 'every sort of compliment'.

Rubens was reluctant. Italy called him back. If he were to settle in Flanders, he would anyway not choose to live at court, in Brussels. He would prefer to settle in Antwerp, where his brother Philip had just been appointed city

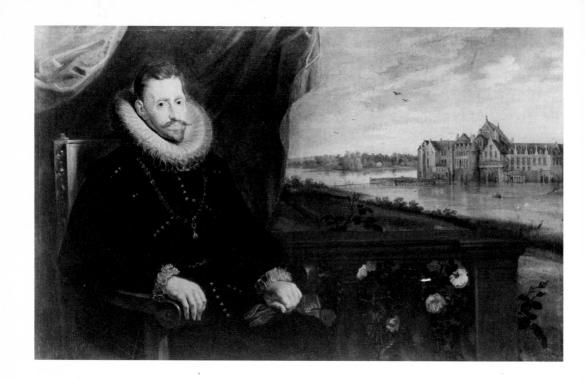

secretary. The offers of the archduke, he admitted, were 'very generous, but I have little desire to become a courtier again. Antwerp and its citizens would satisfy me, if I could say farewell to Rome.' But then he added a significant phrase. 'The peace', he wrote, 'or rather the truce for many years, will without doubt be ratified, and during this period it is believed that our country will flourish again.'[4]

The return of Rubens to Flanders at the end of 1608, the pressure on him to enter the archduke's service, and the twelve-year truce of 1609 are all intimately connected. No doubt they were connected in the archduke's mind. Like all his family, the archduke was a connoisseur and a collector. In his residence of Tervuren alone, he had 200 works of art, and more elsewhere: in Mary of Hungary's castle of Mariemont and in his palace in Brussels. Many of these were old Netherlands or German masters. Among living artists he had hitherto shown a preference for mannerists formed in the Roman school, like van Veen. He enjoyed the company of van Veen, the polished humanist and man of the world. But Rubens too was a polished humanist, accustomed to court life. It seems clear that the archduke had intended to recall Rubens even without the accident of his mother's illness: he had been in touch with him while Rubens was still in Italy.[5] He was thinking of the work ahead, the work of reconstruction, in the years of peace.

Nor was it only Rubens whom the archduke was resolved to use in those years. He was well aware of the ruin caused by the long war and was deter-

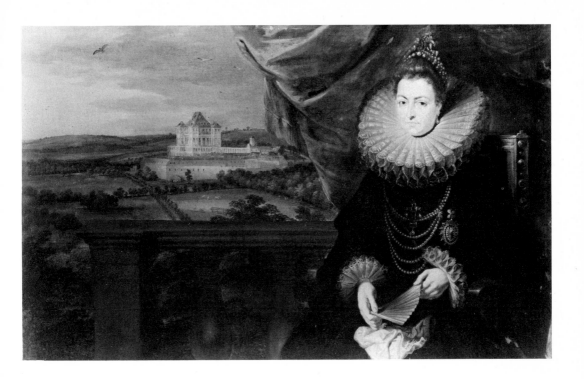

Rubens and Jan Brueghel, portraits of 'The Archdukes', Albert of Austria (with the castle of Tervuren in the background) and the infanta Isabella (with Mariemont in the background).

mined to reverse the flight of talent from the Netherlands. Already he had taken steps in this direction. In 1604 he had called back Wenzel Coebergher, an architect, painter and engineer who had left Antwerp in the 1570s and spent twenty-five years in Rome and Naples. Coebergher was now court-architect in Brussels. He too was a cultivated man of wide, cosmopolitan learning, known and admired in the polite society of Italy. He would become the builder of churches and the drainer of the fens in the archducal Nether-lands. And then there was the landscape-painter Jan Brueghel, known as 'Velvet Brueghel', the younger son of the great Pieter Brueghel the Elder. He too had emigrated to Italy during the war and had entered the service of Federigo Borromeo, archbishop of Milan. He had returned to Antwerp in 1596 and had become a member of the corporation of painters and a citizen of the city. Rudolf II, as we have seen, had tempted him occasionally to Prague. Now, in the same year, 1609, the year of the truce, he too was cap-tured by the archdukes, appointed court-painter and commissioned to paint a series of landscapes for them.

Thus the invitation to Rubens in 1609 falls into place as part of a deliberate plan by the archdukes who, having at last achieved peace in the Netherlands, were eager to restore the lost prosperity and the lost artistic splendour of the Burgundian court. Rubens was clearly aware of their intention and his opportunity. He overcame his doubts and accepted the appointment, which was given to him with a special dispensation to live not at Brussels but at

Antwerp, and to teach his art free from all guild restrictions. Thus was set up, in Antwerp, the most famous artists' workshop since the death of Titian thirty-three years before.

The four artists whom I have named – Otto van Veen, Wenzel Coebergher, Jan Brueghel and Rubens – formed the artistic court of the archdukes during the years of the truce. They all knew each other well. Rubens was the pupil of van Veen. He was the collaborator of Coebergher, who built the churches which he decorated. He was the intimate friend of Brueghel. Not only did he paint pictures jointly with Brueghel – *The Garden of Eden* in the Mauritshuis at The Hague is one such joint painting, the *Feast of Acheloüs* at the Metropolitan Museum in New York is another – he also, for many years, acted as Brueghel's Italian secretary: almost all Brueghel's letters to his old patron cardinal Borromeo in Milan, are in Rubens' hand, and when Rubens was absent from Antwerp, the correspondence was suspended. We are told that the archduke particularly enjoyed relaxing after dinner in the company of these four artists.[6] But there can be no question who was the dominant figure among them. For it was Rubens, by far the youngest of the four, who brought to Antwerp the new dynamic spirit, the energy of thought and composition, which was to give its character not only to the last great age of Flemish Renaissance art but to a whole period of artistic history.

Did the archduke realise the revolution he was causing when he brought Rubens into his court? Did he suppose that, in preventing his return to Italy, he was doing more than all his family for the artistic glory of the Netherlands? Perhaps not. Like his brothers, the Emperors Rudolf and Matthias, he was an eclectic in his tastes, a patron of mannerism. He was also a docile, perhaps an unimaginative, son of the Church. He had been a cardinal until he was required, for reasons of state, to marry the infanta, and as Philip II's viceroy of Portugal he had presided happily over the operations of the newly reinvigorated Inquisition in Lisbon. Rubens, absent in Italy, was perhaps known to him only as an able young painter, a pupil of Otto van Veen, who had given satisfaction in his patrons in Italy and in Spain, just as his brother, the Emperor Rudolf, had also heard of him through his artistic factotum Hans von Aachen, who had met him while on a visit to Mantua. At Aachen's suggestion, Rudolf had sent a commission to Rubens. It was not for an original painting. Typically, the Emperor used Rubens only to copy two paintings of Correggio in Mantua. Left to himself, Rubens preferred to copy Titian. It may well be that the archduke's impulse was like that of his brother: that he expected a docile imitator of Correggio, a true disciple of van Veen. If so, he must have been surprised by the result.

The first and most obvious area in which Rubens showed his talents was that of religious art. The southern Netherlands, reconquered and held by the arms of Spain, were not only the bastion of the Spanish empire in northern Europe, the 'ancient patrimony' of the house of Habsburg; they were also the power-house, and the shop-window, of the Counter-Reformation in the

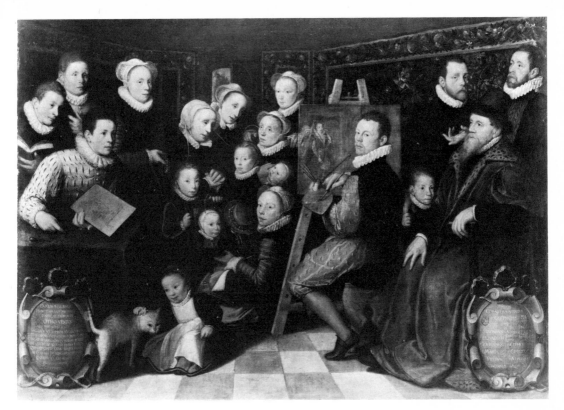

Protestant lands. So, in those years of peace, so long delayed, the Catholic
Church exerted itself to recover lost ground, to build up its forces, and to
display its charms. In the years of reconquest, the active Protestants had been
driven out and Catholic missionaries brought in. In the years of peace,
under the zealous patronage of the archdukes, Catholic life and worship were
restored, new religious orders flooded in, new churches were built and
decorated, the wounds inflicted by war and iconoclasm were healed. From
being the theatre of desolation, the southern Netherlands became the model
of a triumphant Catholic society, confident and aggressive, the centre from
which missionaries set out to dazzle, seduce and reconvert the Protestants of
England, Holland and Germany. In this work of Catholic restoration the
arts were a powerful force. They were its propaganda. Whatever Protestantism
had attacked, Catholicism must reassert: the cult of images, of the Virgin,
of saints, of relics, of the specifically Catholic mysteries, disputed doctrines,
doubtful miracles, heroic martyrdoms; and it must reassert them visibly,
vividly, powerfully, with conviction. For his aristocratic lay patrons, weary
of doctrinal strife, eager to relax in that luxuriant Indian summer of the
Pax Hispanica, the humanist Rubens would paint scenes from antiquity or
pagan mythology in which the prudish and exacting Church of the Counter-
Reformation did not interfere. Nudity, banned from religious scenes, could
here be savoured to the full. For his clerical patrons he would produce those

Otto van Veen (1556–
1629), *The Artist and
His Family.*

143

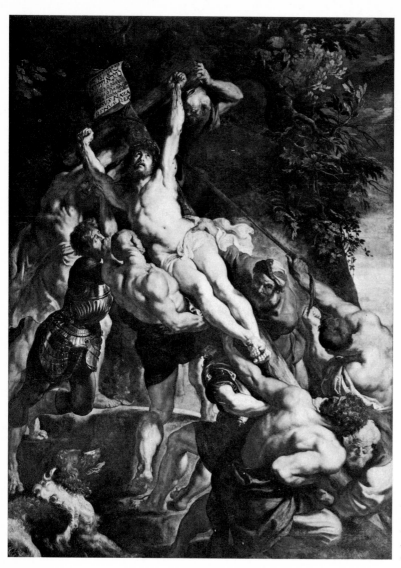

Rubens, *The Raising of the Cross*, c. 1609–10, and (opposite) *The Descent from the Cross*, c. 1611–14.

monumental altarpieces, and those scenes from sacred history in which the fierce energy of Caravaggio was harnessed to the Church Triumphant, and documented, in every detail, by the great doctors of the Counter-Reformation. In 1611, in Rome, the apparent triumph of the Catholic Church over European heresy was signalised by the consecration of the great new church of Sta Maria Maggiore. Among its erudite propagandist frescoes, Giovanni Baglione depicted the painful deaths of the iconoclast emperors of Byzantium. Meanwhile, in reconquered Flanders, Rubens was illustrating the defeat of iconoclasm by painting, for the churches of Antwerp, his spectacular works *The Raising of the Cross* and *The Descent from the Cross*.

In this work of spiritual reconquest, the most aggressive and successful force was that of the Jesuits. They were the shock-troops of the Counter-

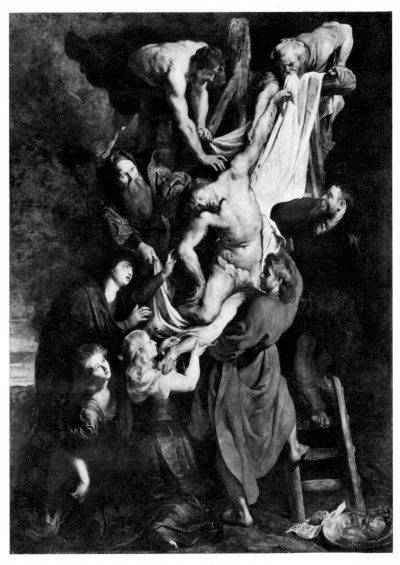

Reformation, and nowhere had they been more effective than in the Netherlands. They were also the favoured order of the archdukes. Under the rule of the archduke Albert alone – that is, from 1598 to 1621 – they multiplied fourfold in numbers. They acquired vast wealth and influence, and in return they were the most devoted supporters of the régime, preaching absolute obedience to the house of Austria. Their ambitions, and their pretensions, were unlimited. They dominated the intellectual life of the country. They imposed their new Italian architecture upon it. They controlled education, literature, the arts. It was they who had enslaved the aged Lipsius. They would soon enslave the infanta. Inevitably they became the patrons, though never the masters, of Rubens, and it was from them that he received the most grandiose of his church commissions.

For in Antwerp, as elsewhere, the Jesuits were now building a new church, and they were determined that it must eclipse all other churches as they eclipsed all other orders. It was designed by one of their own members, the most famous of many Jesuit architects, Brother Pieter Huyssens, in imitation of the Gesù in Rome, and it would be dedicated, when complete, to the newly canonised founder of the order, St Ignatius Loyola. Rubens undertook to supply two alternative altarpieces, the *Miracles of St Ignatius* and the *Miracles of St Francis Xavier*, and thirty-nine ceiling-paintings. His workshop was kept busy, all hands to the task (including those of his pupil van Dyck) for several years. When the church was consecrated, visitors were dazzled by its splendour: by the weight of gold and marble and particularly (as the English ambassador wrote) by the 'brave pictures of Rubens' making, who at this time is held the master workman of the world'.[7]

Others were staggered by the cost. Among them was the general of the order in Rome. Such luxury and ostentation, he thought, somewhat damaged the ideal of Christian poverty which the Jesuits professed; and he forbade the building to be opened. He also had Brother Huyssens sent off to a monastery and ordered him to give up the practice of architecture. However, the infanta (for the archduke was now dead) soon stopped all that. She got Huyssens out of his seclusion, put him back into business, had him design her own chapel, sent him to Italy to study the best models and fetch the most expensive marble, and watched with satisfaction while he built his new masterpiece, St Peter's at Ghent.[8] Here too Rubens collaborated with him. It was he who advised the infanta, and it was he who would decorate the new church with his splendid but terrible painting *The Martyrdom of St Lievin*.

In his great altarpieces and religious paintings, Rubens put his extra-ordinary powers behind the efforts of the Counter-Reformation Church, of which the archdukes were the patrons. But there was another cause which, to him, was almost as important – and certainly more important than the mere pride and vainglory of the Jesuits, which he was quick to see through and despise. This was the cause of peace: peace in the Netherlands, peace in Europe. In this too he found himself in agreement with the archdukes.

The archdukes had made the truce of 1609 which had tempted Rubens to stay in Flanders. It was they who had exploited that truce for the restoration of their country and the settlement of their church. The splendour of their court, which was regarded as the most regular and magnificent in Europe, depended on peace. So, when the truce was due to run out after twelve years, the archduke worked hard to renew it. He did not succeed. In 1621, the very year of its expiry, new men came to power in Madrid: a new king, Philip IV, and a new minister, the count-duke of Olivares. With that change of rulers, the ambitions of Philip II were revived, the truce was allowed to lapse, and the war in the Netherlands was resumed. Soon it would be merged with the war in Germany, the Thirty Years War. In that long war – the second lap of the eighty-years revolt of the Netherlands – the prosperity of Belgium, so

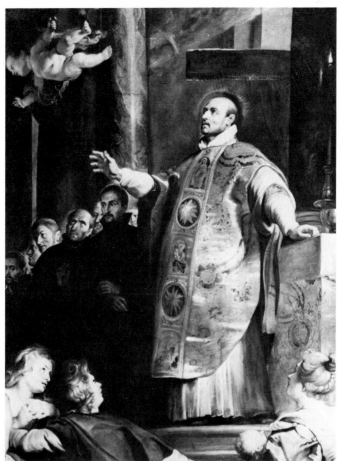

Rubens, *The Miracles of St Ignatius*, from an altarpiece begun in 1620.

W.S. von Ehrenberg (1637–76), *The Jesuit Church in Antwerp*. Rubens' altarpiece can be seen *in situ*.

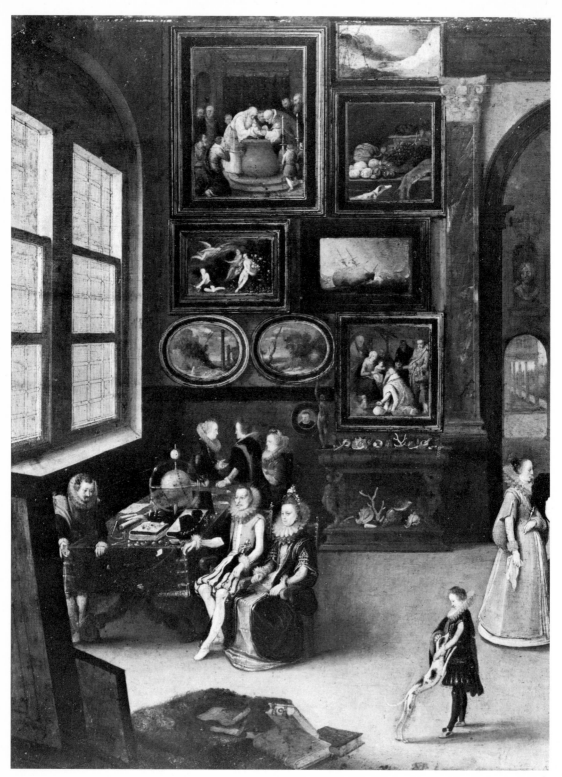

148

brilliant but so fragile during the reign of the archdukes, would be destroyed.

In 1621, the year of renewed war, the archduke Albert died. As he lay dying, he urged the infanta, who would now be left to rule alone, to rely henceforth on the advice of Rubens, whose ideals were so similar to his own, whose diplomatic gifts had already been proved, and whose profession gave him access to so many of the art-loving statesmen and courtiers of the time. Such reliance was not welcomed by the great Burgundian noblemen who claimed a monopoly of political influence at court. But Rubens was fortunate in having the support of Ambrogio Spinola, the Genoese commander of the Spanish army in the Netherlands who was also a consistent advocate of peace in the north. Between 1621 and 1633, the infanta sent Rubens on three secret missions to Holland and one to Germany, and in 1628 Spinola persuaded Philip IV to summon Rubens to Spain and to send him as ambassador extraordinary to England. On each of these occasions Rubens was seeking to make peace: peace with Holland, peace with England. This had always been the archduke's policy; it was that of the infanta; it was also his own.

For Rubens detested war which had been the ruin of his country and which, he believed, was the ruin of civilisation. In this he was following his masters, Erasmus and Lipsius. Sometimes his words seem to echo Erasmus' fierce denunciations of carnivorous war-loving kings. Like these precursors, Rubens believed essentially in the unity and peace of Christendom. The Roman Empire, which the humanists sought to revive, was worthy of revival, in their eyes, for the sake of the *Pax Romana* which had protected its high culture; and similarly to Rubens, though he did not love Spain, the *Pax Hispanica* justified the Spanish domination in Europe. 'Today', he once wrote, 'the interests of the entire world are closely linked together', and therefore peace was a necessity. Unfortunately, he added, the great powers 'are governed by men without experience and incapable of following the counsel of others': thus they do nothing to end 'the miseries of Europe'.[9]

Again and again, in his letters, Rubens declaims against war and war-mongers. 'Surely it would be better', he wrote, 'if these young men who govern the world today' – he was referring to the kings of France and Spain – 'were willing to maintain friendly relations with one another instead of throwing all Christendom into turmoil by their caprices.' The men of the war party in Spain, who claimed that war was necessary to secure the triumph of religion, got short shrift from him. 'They are the scourges of God', he wrote, 'who carry out His work by such means.' For although Rubens was a devout Catholic, who heard mass early each morning before beginning his work, and put his gifts at the service of the Catholic reconquest, his personal letters show no commitment to Tridentine doctrine, and he detested sectarian war. Again like Erasmus and Lipsius, and like his Dutch friend Hugo Grotius, he was fundamentally ecumenical in his views, willing to allow superficial diversity of belief. Indeed, it was one of the objections to

The archdukes Albert and Isabella visiting Rubens' studio; detail from a painting by Hendrik Staben.

149

neo-stoicism that it was, at bottom, a tepid form of Christianity, 'made for rational men, for intellectuals, who will always reason . . . but who will never be carried away by the madness of the cross'.[10] Such views were incompatible with persecution or wars of religion, especially as such wars were being fought in his time. Rubens complained bitterly about the methods used by the military commanders on the Catholic side. The Imperial general Wallenstein, he wrote, 'conducts himself like a tyrant, burning villages and towns like any barbarian'. The greatest painter of theatrical battle-scenes had no illusions about the real nature of seventeenth-century war.[11]

The climax of Rubens' diplomatic career was his mission to England in 1629–30. Two years earlier, when Philip IV had first heard that the infanta was using Rubens as a secret diplomatic agent, he had objected. Affairs of such importance, he wrote, should not be entrusted to 'a painter'. But the infanta stood her ground: Charles I of England, she pointed out, was also using a painter, the cosmopolitan dilettante Sir Balthasar Gerbier, who was Rubens' contact. By now the king of Spain accepted the situation. Rubens was summoned to Spain and thence sent to England as ambassador extraordinary, with a title of nobility. His instructions were to negotiate peace between the two countries. This he achieved; and his heirs were so proud of his achievement that they would cause it to be specially recorded on his tomb.

Rubens certainly had grounds for self-satisfaction. He was pleased to be a peacemaker. But to him peace with England was only a beginning. His own hope was that it would lead to a general peace, and so give relief to Flanders, and especially to Antwerp, which was being destroyed by the war. 'Our city', he wrote, 'is going step by step to ruin and lives only upon its savings: there is not the slightest trade to support it'; and again, 'This city is languishing like a consumptive body, declining little by little. Every day the number of its inhabitants decreases, for these unhappy people have no means of supporting themselves either by industry or by trade.' But that was not the aim of Olivares: it soon became clear that that ambitious minister only sought to free himself from war against England so that he might strike harder in the Netherlands, while the court of Spain, which might have controlled these bellicose plans, was quite unable to do so, being 'sunk in a profound lethargy'. Thereupon Rubens acted on his own. He called secretly on the Dutch ambassador in London and told him that the northern Netherlands 'might have peace if they would, and thereby bring quiet and rest after long war to all the 17 Provinces'. The move was unavailing. There was but one way to such relief, he was told, and that was 'by chasing the Spaniards from thence'. In his heart, Rubens agreed. Spanish domination might have preserved the Church, but Spanish war was ruining Flanders as it was ruining Italy.[12]

After Rubens' success in London, Philip IV (who of course knew nothing of his private diplomacy) dropped all objections to using 'a painter' in these high matters, and wished to make his appointment permanent. One

Rubens, *Triumph of the Eucharist over Ignorance and Blindness* and *The Victory of the Eucharist over Heresy*; coloured sketches on wood for a series of tapestries commissioned about 1625 by the infanta Isabella.

of the Spanish councillors objected that Rubens 'practised an art and lived by the product of his work', but the king insisted that Rubens was highly regarded at the court of Charles I, had proved his diplomatic skill, and 'in such matters one needs ministers of proven intelligence with whom one is satisfied'. However, Rubens was reluctant to go back and the infanta supported him. For another four years he served her in diplomacy, always seeking an end of the ruinous war with Holland. Then, frustrated in his aims, insulted by the Flemish nobility, and eager to concentrate on his art, he secured his release. In his own words, 'I made the decision to cut this golden knot of ambition in order to recover my liberty', and so 'I seized the occasion of a short secret journey to throw myself at Her Highness' feet and beg, as the sole reward for so many efforts, exemption from such tasks and permission to serve her in my own home. This favour I obtained with more difficulty than any other she ever granted me.'[13]

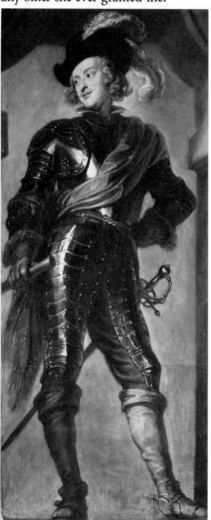

Rubens, portrait of the cardinal-infante don Fernando.

That was in 1633. Later in the same year the infanta died. She had been a generous patron, like her husband, but her taste had been essentially, and increasingly, for religious works. If she commissioned a great cycle of paintings it did not represent scenes from Roman antiquity, or the glory of a dynasty, but the progress of the Counter-Reformation, the victory of the Eucharist over Paganism, Ignorance and Protestant heresy. After her death, the court of Spain sent Philip IV's younger brother, the cardinal-infante don Fernando, to succeed her as governor, and Rubens' workshop supplied the *décor* for his triumphal entry. Among the lavish imagery which glorified, once again, the house of Habsburg – the long line of Emperors and kings from Rudolf I to the present, the mythological scenes, the personal history of the cardinal-infante culminating in his recent victory over the hitherto invincible Swedish army at Nördlingen – there was a 'Stage of Mercury', which represented the god of commerce departing from impoverished Antwerp.[14]

Rubens, *Mercury deserting Antwerp*, design for the pageant devised for the entry of don Fernando into Antwerp, 1635.

The cardinal-infante continued the patronage of his uncle and aunt, the archdukes. He made Rubens his court-painter. It was he who commissioned him to supply the decoration for the royal hunting-lodge in Spain: that country chalet of la Parada where some of Rubens' famous hunting scenes were to complement Velazquez's charming portraits of the young Spanish princes equipped for the chase.[15] But he did not seek to bring him back into diplomacy. By this time Rubens was in semi-retirement. As his first biographer put it, seeking 'still greater tranquillity in life than he enjoyed, he bought the estate of Steen, situated between Brussels and Malines, where he sometimes retired in solitude and where he liked to paint landscapes from Nature, that lie of the country being agreeable and a mixture of meadows and hills.'[16] So in his last years the greatest of court-painters became one of the most perfect of landscape-painters; so also, as he wrote, 'by divine grace, I have found peace of mind, having renounced every sort of employment outside of my beloved profession'.[17]

We are concerned not with Rubens as a diplomatist but with Rubens as an artist, and with his art as the expression of the ideas which he served. But in him diplomacy and art were never far removed from each other. His was a total philosophy, and the passion for peace which animated him, as a native Netherlander, as it also animated his royal patrons, who had become Netherlanders by adoption and sympathy, is clear in his paintings too. Formally, Rubens is the painter of the Counter-Reformation; but I have suggested that this is rather a response to patronage than an expression of personal commitment. His deepest personal commitment was to peace. He is the painter, as well as the diplomatist, of European peace.

In 1621, on the day after the consecration of the Jesuit church in Antwerp, with his splendid ceilings and altarpieces, Rubens wrote to an English friend, Sir William Trumbull, a letter which at the same time reveals his marvellous confidence in his own powers and points forward to one of his most famous works. Trumbull was an agent of king James I and had sounded Rubens about a new project, another great ceiling-painting, for the Banqueting House at Whitehall, newly rebuilt by Inigo Jones. In his reply, Rubens expressed his willingness. 'I confess', he wrote, 'that I am by natural instinct better fitted to execute very large works than small curiosities. Everyone according to his gifts; my talent is such that no undertaking, however vast or various, has surpassed my courage.'[18] The ceiling which Rubens ultimately painted for Whitehall – he designed it when he came as ambassador in 1629 and completed it in 1634 – was the apotheosis of king James as *Rex Pacificus*, the royal peacemaker. In London he also painted, as a present to Charles I, his allegorical work *Peace and War*.

Meanwhile, almost immediately after his letter in 1622 accepting the London commission, Rubens began, for Marie de Médicis, the queen mother of France, another huge project. This was the first of his two great series of paintings for her new palace, the Luxembourg, in Paris. These

Rubens, design for the Apotheosis of James I of England.

154

paintings represented – where Rubens was free to choose his subject – 'the flowering of the Kingdom of France, with the revival of the sciences and the arts' during the pacific regency of the queen mother. Finally – perhaps in the later series, unfinished owing to the dramatic intervention of Richelieu, who drove Marie de Médicis into exile in the Spanish Netherlands – he painted a dramatic allegorical work *The Horrors of War*. In a letter to a friend he described and interpreted the allegory: the monsters who personify 'Pestilence and Famine, those inseparable partners of War', and the symbols which show that, in time of war, all arts and letters are trodden underfoot. As for 'the grief-stricken woman clothed in black, with torn veil, robbed of all her jewels and other ornaments', she is 'the unfortunate Europe who, for so many years now has suffered plunder, outrage and misery . . .'[19] The horrors of the Thirty Years War provoked several great works, both of literature and of art: one of them was the first classic work of international law, the *De Jure Belli et Pacis* of Rubens' Dutch friend Hugo Grotius. Another was this great allegorical painting which Jacob Burckhardt describes as 'The immortal and unforgettable frontispiece to the Thirty Years War, painted by the hand of him who was alone, in the highest sense, called to paint it.'[20]

Of course it can be said that Rubens' idea of peace reflects the interest of his patrons: that peace, for him, meant the *Pax Hispanica* of 1609 which he did not wish to see disturbed. Were not the archdukes the beneficiaries of that peace? Did not James I in England and Marie de Médicis in France bask in Spanish patronage? Were not all Rubens' political patrons – the duke of Mantua, the duke of Neuburg, the duke of Bavaria, the grand dukes of Florence, the financial aristocracy of Genoa – clients of Spain? And did not the real crime, the machiavellian *raison d'état*, of his *bête noire*, cardinal Richelieu, consist ultimately in his refusal to accept that Spanish hegemony, his single-minded application of 'all his industry and power to undermine, insult and abase the monarchy of Spain'? Richelieu himself certainly regarded Rubens as a politically committed artist. At first, he admired Rubens' work, and commissioned a painting from him; but afterwards he turned against him and tried to have the contract for the second great cycle of paintings for Marie de Médicis, *The Triumphs of Henri IV*, transferred to a second-rate rival, the aged mannerist cavaliere d'Arpino. Since Richelieu was himself a man of exquisite taste, this can only be explained by political reasons. Richelieu's nephew, it may be added, tried afterwards to rectify his uncle's error. He admired Rubens above all other artists, as the only universal master, and when he could not buy his paintings in the open market, owing to the jealousy of their Belgian owners, who would not surrender such treasures, he adopted more forcible methods and relied on 'the rapid con-quests of our invincible monarch', Louis XIV, to fill the château de Richelieu with captured trophies.[21]

Undoubtedly there is some truth in this view. Rubens was a man of his time, and his time was the time of Spanish domination. Little though he

Rubens, sketch for *The Peaceful Reign of Marie de Médicis*.

Rubens,
Peace and War.

loved Spain, he preferred Spanish supremacy to European war, and wished
to see it continued. At one moment, in his hatred of Richelieu, who was
undermining that supremacy, indirectly, at all points, he even turned war-
monger himself: he urged Olivares to save the threatened *Pax Hispanica* by a
'pre-emptive strike', by making open war on France. This was in 1631, when
Richelieu, having committed himself to a policy of total resistance to the
house of Habsburg, drove Marie de Médicis, as the most dangerous enemy
of that policy, out of France. The fugitive queen took refuge in Flanders,
under the protection of the infanta; and Rubens urged that she be restored
by force of Spanish arms. In other words, he urged that Philip IV intervene

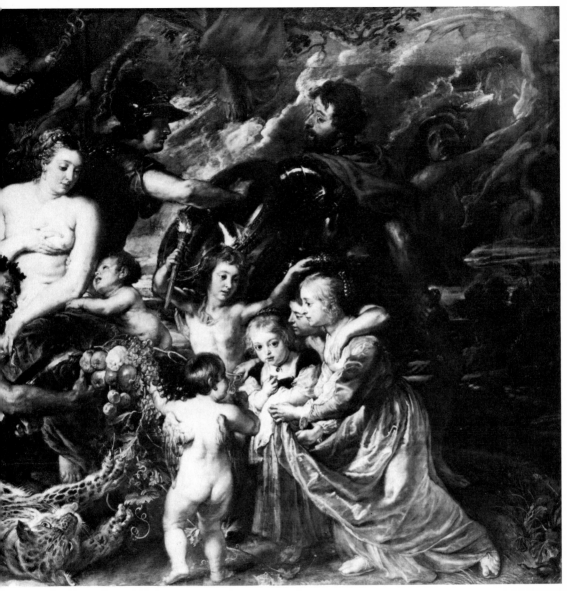

in France, as Philip II had done in the 1580s, in order to destroy the anti-Spanish party there and sustain in power the party of the *dévots*, the appeasers of Spain. By timely intervention now, Olivares, said Rubens, could turn the balance in Europe before it was too late. A short, successful war, and the *Pax Hispanica* could be saved: indeed, generalised throughout Europe, to the benefit of all, and particularly of Flanders. 'It would be desirable', he wrote, 'if the affair succeeds, that there should finally be a good general peace, at the expense of the cardinal, who keeps the world in a turmoil: a peace involving France and England, and not only in Flanders but also in Germany and throughout all Christendom. I hope that the Lord God has reserved

159

this task for your Excellency who, for piety and holy devotion to the service of his divine Majesty and of our King, deserves this greater glory of being the sole instrument of such a great good work.'[22]

However, if it is true that Rubens was the artistic propagandist of the *Pax Hispanica*, it would be absurd to suggest that this is the whole truth. Like all great artists, he was independent of patronage: that is, he used his patrons as much as they used him. And how skilfully he used them to forward his art! Even diplomacy was used for that purpose. Never was Rubens more active as an artist than when he was also engaged in diplomacy. Diplomacy indeed increased his artistic opportunities. His first diplomatic mission to Spain, in 1603, had enabled him to study the work of Titian. When the infanta sent him to Holland, he used the opportunity to meet the Dutch artists. In Spain, in 1628, he painted the royal family, discovered Velazquez, and was taken by him to the Escorial to copy the Titians which Philip II had assembled there. Philip IV, that art-loving king, placed him in his own palace so that he could visit him daily. England offered similar opportunities. Charles I was delighted when he heard that Rubens was coming as ambassador, because, as he said, 'he wishes to know a person of such merit'; and Rubens was no less delighted to find such unexpected charm, such rural beauty, such politeness, such culture and love of art in 'a place so remote from Italian elegance'. In the intervals of diplomacy, he painted half a dozen masterpieces there too.

In every capacity, Rubens towers over his patrons. His enormous correspondence, of which only a precious fragment remains – a mere 250 out of 8,000 letters – knows no ideological frontiers: his Catholicism disdains the limits of contemporary orthodoxy; his stoicism transcends the cold imperturbability of his master Lipsius. He fits into no neat category. He is a law to himself. Wherever we discover him, his stature, his range and versatility astonish us. Sometimes we see him in his splendid town-house in Antwerp, the most famous in the city, with its portico and garden, its antique statues and modern pictures. Over the central door is the inevitable bust of Seneca and on the summer-house in the garden are inscribed the most famous verses of Juvenal – 'the most consoling that Latin poetry has given us' as Burckhardt calls them – the motto of the stoic sage:

> Orandum est ut sit mens sana in corpore sano.
> Fortem posce animum mortis terrore carentem . . .

Or shall we visit him in his country-house, the castle of Steen, so familiar to us from those enchanted landscapes of his last years, which were to be the inspiration of Constable; or envisage him riding the fine Spanish horses which he kept to draw from the life, or sitting in his workshop, dashing off an *Adoration of the Magi* as a present to the Italian doctor who treated his gout, dictating letters in six languages, conversing with his visitors, and listening, as he painted and spoke, to his hired reader reciting passages from 'some good

book', ordinarily Plutarch, Livy, Tacitus or Seneca? For always it is the great writers of the Roman Empire, the stoic philosophers of the Silver Age, who inspired Rubens, as they had inspired Lipsius: Lipsius the philosopher who defined, Rubens the artist who, by his universality, transcended the Silver Age of the European Renaissance.

Rubens, self-portrait with his second wife, Hélène Fourment, and their son Nicholas, walking in their garden in Antwerp, c. 1631.

For Rubens, like Leonardo, or Michelangelo, is a universal man, the last universal man of the Renaissance; and the royal patrons of that time, we should not forget, were, in their way, universal men too. When we think of Charles V courting Titian, of Philip II breathing down the neck of Tibaldi, of Rudolf II shut in the Hradschin with his mannerist artists, of the archduke Albert relaxing *post prandium* with Rubens and Jan Brueghel, of Philip IV closeted with Rubens or climbing ladders to discuss details with his Bolognese ceiling artists, we are bound to remark that times have changed. This is not what we expect of our political leaders today.

We may speak of the 'style' of a modern politician, but that is not what we mean. In aesthetic matters our modern leaders, we must admit, generally have no style at all; or, if they do – as Hitler and Stalin did – it is not such as posterity will recall with pleasure. Albert Speer, as he was forced to admit,

161

was no Herrera; and it is doubtful whether the socialist realist artists patronised by Stalin will ever be mentioned in the same breath as Titian or Rubens, or even as the mannerists of Prague.

When we ask the reason for this change, answers easily suggest themselves. Much may be ascribed to mere fashion: much, but not all; for how did the fashion arise, and why was it so catching? We may allow that hereditary monarchy had something to do with it. The hereditary rulers of the past knew their future, and their education was adjusted accordingly: how seriously young princes were then initiated into the living philosophy and culture of their time! Our modern leaders are seldom so prepared: they are sometimes so preoccupied by the competitive race for power that they have no op-portunity to prepare themselves aesthetically for its exercise. But even this is not a complete explanation, for there were hereditary rulers in the nineteenth century, and the formula does not apply to them. There had been a change, not in the hereditary system but in the taste, the education, of its representa-tives. These therefore are partial explanations which cannot satisfy us. The central explanation, if there is one, must be sought elsewhere.

It must be sought, I believe, in the mental world, the 'world picture' of the age. Art, in the sixteenth century, had a wider function than art in the nineteenth century. It symbolised a whole view of life, of which politics were a part, and which the court – that all-embracing Renaissance court which had taken over the patronage of the Church and had set a pattern for all subordinate hierarchies – had a duty to advertise and sustain. Since then, since the mid-seventeenth century – always we come back to that watershed of intellectual history – that undivided world picture has been broken up: art has gradually become the special subject of artists or art-experts, literature of philologists, politics of politicians; and although the grim ideologues of our century have sought artificially to restore the lost unity, that brutal experiment has not been, artistically, a success. Whatever we may say of their politics, the aesthetic propaganda at least of the house of Habsburg has been more persuasive than that of the German master-race or the Soviet workers' paradise.

It was not propaganda for a single, or even a consistent cause. Various themes run through it: the dream of universal empire, the glory of a particular dynasty, successive ideas of society, of religion, of nature, the crusade for religious unity, military triumph against the infidel, the preservation of European peace. But at least it was consistent in one respect: it mobilised the art and artists of the age, gave them their stimulus and opportunity, and, while supplying them with its own themes, left them sufficiently free to realise their own genius. Without that patronage, how different the art of that century would have been.

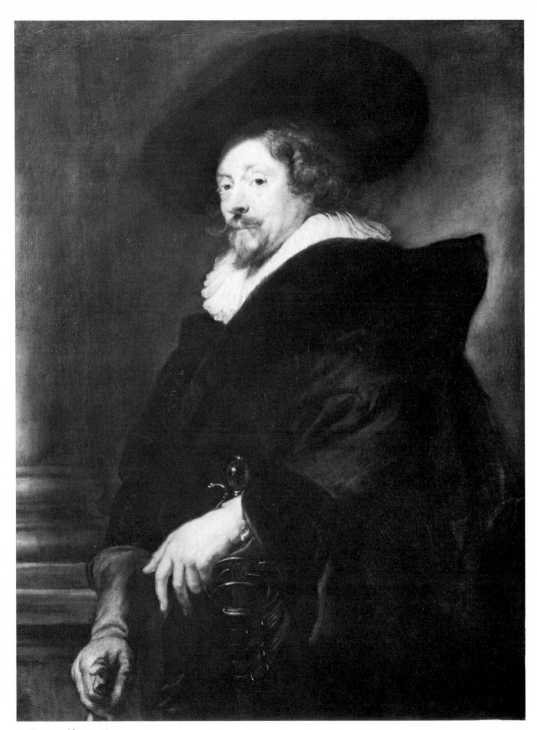

Rubens, self-portrait, 1638–40.

Bibliographical notes

GENERAL

The basic works which I have used for these lectures are Alphons Lhotsky, *Geschichte der Sammlungen* (Vienna, Festschrift des Kunsthistorischen Museum 1941–45) and the *Jahrbuch der Kunsthistorischen Sammlungen des allerhöchsten Kaiserhauses* (Vienna 1883–), continued after 1918 as *Jahrbuch der Kunsthistorischen Sammlungen in Wien*. (When referring to this series in the following notes I have consistently abbreviated the title to *Jahrbuch*.) Important contemporary sources are (for Italian painters) Giorgio Vasari, *Lives of the Painters*, and (for northern painters) Karel van Mander, *Het Schilderboek* (Haarlem 1604), English translation by Constant van de Wall (New York 1936). The following are the main sources which I have used for the individual chapters.

CHAPTER I

The imperial ideal of Charles V has been set out, with different emphasis, in Peter Rassow, *Die Kaiseridee Karls V* (Berlin 1932); R. Menéndez Pidal, *La Idea Imperial de Carlos V* (Madrid 1940); and, most recently, Frances Yates, *Astraea: The Imperial Theme in the Sixteenth Century* (London 1975). I know no general work on Charles V as patron, but there is useful material in the catalogue of the Charles V exhibition at Vienna on the quatercentenary of his death (*Sonderausstellung Karl V*, Vienna, Kunsthistorisches Museum, 1958), to which Alfons Lhotsky wrote a brief introduction, reprinted in his *Aufsätze und Vorträge* (Munich 1970–74) II, 328. For Charles V's patronage of Titian, I have used the standard works: J. A. Crowe and G. B. Cavalcaselle, *The Life and Times of Titian* (1877), and Hans Tietze, *Tizian, Leben und Werk* (Vienna 1936); also Pedro Beroquí, *Tiziano en el Prado* (Madrid 1927), Herbert von Einem, *Karl V und Tizian* (Cologne 1958), and Manuel A. Zarco della Valle, 'Unveröffentlichte Beiträge zur Geschichte der Kunststrebungen Karl V und Philipp II', in *Jahrbuch* VII (1888). For the two Leoni there is an excellent study, Eugène Plon, *Leone Leoni et Pompeio Leoni* (Paris 1887). For Jan Vermeyen, his paintings, and the tapestries based on them, see (apart from Mander) Max Friedländer, *Altniederländische Malerei* XII, 157; Heinrich Goebel, *Wandteppiche: die Niederlände* (Leipzig 1923) pp. 419 foll.; J. Houday, *Tapisseries représentant la Conquête du Royaume de Thunes par l'Empereur Charles V* (Lille 1873). The works of Ford and Stirling Maxwell cited by me are Richard Ford, *Handbook for Travellers in Spain* (1845), W. Stirling, *Annals of the Artists of Spain* (1848) and *The Cloister Life of Charles V* (1852). For Antonis Mor, see Henri Hymans, *Antonio Moro* (Brussels 1910); for Mary of Hungary's collections, Alexandre Pinchart, 'Tableaux et Sculptures de Marie d'Autriche, reine douairière de Hongrie', *Revue Universelle des Arts* III, 127. For the 'plateresque' architecture of Spain under Charles V, see José Camón Aznar, *La Arquitectura Plateresca* (Madrid 1945).

The indispensable contemporary account of Philip II's building of the Escorial is José de Sigüenza, *Historia de la Orden de San Gerónimo* (1605), reprinted in Nueva Biblioteca de Autores Españoles (Madrid 1909). There is also an excellent and very readable modern account, based on this and other sources, *viz*: Louis Bertrand, *Philippe II et l'Escorial* (Paris 1929). For an admirable series of essays by experts in every field of art, see the two magnificent volumes published by Patrimonio Nacional to celebrate the quatercentenary of the foundation of the Escorial (*El Escorial 1563–1963*, Madrid 1963). I have profited particularly from the essays of Luis Cervera Vera, Georg Weise, Secundino Zuaze Ugalde, Maria Elena Gómez Moreno, F-J. Sanchez Cantón, and P. Federico Sopeña Ibañez. For Philip II's patronage in general, I have used the still valuable pioneering work of Carl Justi, 'Philipp II als Kunstfreund', in *Miszellaneen aus drei Jahrhunderten Spanischen Kunstlebens* (Berlin 1908). For Titian's early work for Philip II see Harald Keller, *Tizians Poesie für König Philipp II von Spanien* (Wiesbaden 1969). For el Greco I have relied mainly on Manuel B. Cossío, *El Greco* (Madrid 1908), new edition by Natalia Cossío de Jiménez (Barcelona 1972), and José Camón Aznar, *Dominico Greco* (Madrid 1950). For Philip's interest in Bosch see – apart from Justi – Max Friedländer, *Early Netherlandish Painting* V: *Geertgen tot Sint Jans en Jerome Bosc* (Leiden 1969): Mia Cenotti, *The Complete Paintings of Hieronymus Bosch* (English translation 1969). Philip's letters to his daughters are printed in L. P. Gachard (ed.), *Lettres de Philippe II à ses filles* (Paris 1884).

For Rudolf II in general see R. J. W. Evans, *Rudolf II and his World* (Oxford 1973). On his patronage in general, a good account is Karl Chytil, *Die Kunst in Prag zur Zeit Rudolf II* (Prague 1904). On Arcimboldo, I have used Legrand and Sluys, *Giuseppe Arcimboldo et les Arcimboldesques* (Aalten 1955), and Benno Geiger, *I Dipinti Ghiribizzosi di Giuseppe Arcimboldo* (Florence 1954); on Giovanni Bologna, Elizabeth Dhanens, 'Jean Boulogne . . .' in *Verhandelingen van de K. Vlaamse Academie voor Wetenschappen, Letteren en Schone Kunsten van Belgie*, Brussels 1956, and A. Ilg, 'Giovanni da Bologna und seine Beziehungen zum Kaiserlichen Hofe', *Jahrbuch* IV (1886); for Mont, L. O. Larssen, 'Hans Mont van Gent' in *Konsthistorisk Tijdskrift* XXXVI (1967) 1–12 and 'Bemerkungen zur Bildhauerkunst am Rudolfi-nischen Hofe' in *Uměni* XVIII (1970) 172. (This volume of the Czech periodical *Uměni* is devoted to Rudolfine art.) On Spranger, see Ernst Diez, 'Der Hofmaler Bartholomäus Spranger', *Jahrbuch* XXVIII (1909) and Konrad Oberhuber, 'Anmerkungen zu Bartholomäus Spranger als Zeichner', *Uměni* XVIII, 213; on de Vries, A. Ilg, 'Adrian de Fries', *Jahrbuch* I (1883) and L. O. Larssen, *Adriaan de Vries* (Vienna 1967); on Aachen, R. A. Peltzer, 'Der Hofmaler Hans von Aachen, seine Schule und seine Zeit', *Jahrbuch* XXX (1912). On Rudolf's land-scape-painters see Edouard Fétis, *Les Artistes Belges à l'étranger* (Brussels 1857–65); Heinrich Gerhard Franz, 'Niederländische Landschaftsmaler im Künstlerkreis Rudolf II', *Uměni* XVIII (1970) 224–25; An Zwollo, 'Pieter Stevens, ein ver-gessener Maler des Rudolfinischen Kreises', *Jahrbuch* LXXV (1968), and 'Pieter Stevens, neue Zuschreibungen und Zusammenhänge', *Uměni* XVIII (1970) 246; Hans Modern, 'Paulus van Vianen', *Jahrbuch* XV (1894); Teréz Gerszi, 'Die

Landschaftskunst von Paulus van Vianen', *Uměni* XVIII (1970) 260; Kurt Erasmus, 'Roelandt Savery, sein Leben und seine Werke' (Dissertation, Halle a.S. 1908); Musée des Beaux Arts, Gand, 'Roelandt Savery 1576–1638', catalogue 10 April–13 June 1954; J. A. Spicer, 'Roelandt Savery's Studies in Bohemia', *Uměni* XVIII (1970) 270. Rudolf's quest for art-treasures, and his methods of extracting them, are illustrated in the original correspondence ('Regesten') published by H. Zimmermann ('Quellen zur Geschichte der Kaiserlichen Haussammlungen . . .') in *Jahrbuch* VII (2).

CHAPTER 4

For the religious background to Catholic art in the time of the Counter-Reformation, my chief debt is to Emile Mâle, *L'Art Religieux de la Fin du XVI^e Siècle, du XVII^e Siècle et du XVIII^e Siècle* (Paris 1951). For the history of the southern Netherlands, there is the great work of Henri Pirenne, *Histoire de Belgique* vol. IV (Brussels 1927). For the patronage of the archdukes in general, I have used Marcel de Maeyer, 'Albrecht en Isabella en de Schilderkunst', in *Verhandelingen van de K. Vlaamse Academie voor Wetenschappen, Letteren en Schone Kunsten van Belgie* (Brussels 1955). For Rubens in general I have used, especially, his own letters, in the excellent English edition of Ruth Saunders Magurn (*The Letters of Peter Paul Rubens*, Cambridge, Mass., 1955); also the early life of Rubens by Roger de Piles, *Discours sur les Ouvrages des plus fameux peintres* (Paris 1681); Jacob Burckhardt's classic *Recollections of Rubens* (English translation by H. Gerson, London 1950); and the more recent life by H. G. Evers, *Peter Paul Rubens* (Munich 1942). The series *Corpus Rubenianum Ludwig Burchard* (London and New York 1968–) contains valuable specialist studies by J. R. Martin on *The Ceiling Paintings for the Jesuit Church in Antwerp* (Part I), and on *Decorations for the Pompa Introitus Ferdinandi* (Part XVI), and by Svetlana Alpers on *The Decoration of the Torre de la Parada* (Part IX).

Notes on the text

CHAPTER I *Charles V and the failure of humanism*

1. Ariosto, *Orlando Furioso*, canto XV, xxv, xxvi. The whole passage is based on Vergil, *Aeneid* VI, 752–854, *Georgic* II, 474. Cf. Frances Yates, *Astraea: The Imperial Theme in the Sixteenth Century*, ch. I.
2. See L. Venturi, *Storia dell'Arte* IX, 2, 472.
3. Jacob Burckhardt, *Recollections of Rubens*, p. 27.
4. Vergil, *Aeneid* I, 291–96.
5. For details of Titian's relations with the court at Augsburg, see Manuel A. Zarco della Valle.
6. *Ibid.*
7. Henri Hymans, *op. cit.*, p. 123.

CHAPTER 2 *Philip II and the Anti-Reformation*

1. Luis Cervera Vera, 'Semblanza de Juan de Herrera', in *El Escorial* II, p. 18.
2. Ford, *Handbook* I, 56; José Camón Aznar, *La Arquitectura Plateresca*; Georg Weise in *Gesammelte Aufsätze der Görres-Gesellschaft* V (1935), of which a Spanish translation is printed in *El Escorial* II, 273–94.
3. The term 'mannerist' was not used till the nineteenth century. See, in general, John Shearman, *Mannerism* (Harmondsworth 1967).
4. See Secundino Zuaze Ugalde, 'Antecedentes Arquitectónicos del Monasterio de el Escorial', in *El Escorial* II, 105 foll.
5. Letter of Granvelle to Gonzalo Pérez, July 1560, in *Epistolario Español* (Bibl. Autores Españoles, t. LXII) 25–26.
6. Louis Bertrand, *op. cit.*, pp. 47–48.
7. Ford, *Handbook* II, 497–98.
8. Sigüenza, II, 428–31, 613.
9. See Maria Elena Gómez Moreno, 'La Escultura Religiosa y Funeraria en el Escorial', in *El Escorial* II. The detail

about the handkerchief is recorded by Ford (*Handbook* II, 759).

10. Opinions differ widely on the date of this picture, absurdly known as 'The Dream of Philip II'. Manuel Cossío (185–86) maintained to the end of his life, but 'con toda clase de respetos y de reservas', that el Greco painted it after Philip's death, perhaps (since it is not mentioned by José de Sigüenza) after 1605. On the other hand, señor José Camón Aznar (*Dominico Greco*, 219–36) argues for an early date and suggests that it was el Greco's *prueba*.
11. The statue is in the possession of the dukes of Alba in the Palacio de Liria in Madrid.
12. Sigüenza, II, 545.
13. Gachard, *op. cit.*, p. 187.
14. Sigüenza, II, 635–36.

CHAPTER 3 *Rudolf II in Prague*

1. See Lhotsky, *op. cit.*, 157 ff.
2. See L. Pastor, *History of the Popes* XVII, 208 n.
3. This is the view expressed in the best general history of Germany in the period, Moriz Ritter, *Deutsche Geschichte im Zeitalter der Gegenreformation und des Dreissigjährigen Krieges* (1889–95), whence it has invaded German historiography. Cf. Evans, *op. cit.*, p. 49 n. 7.
4. This is the view of Lhotsky, *op. cit.*
5. Evans, pp. 33, 89, 241.
6. See L. O. Larssen, 'Hans Mont van Gent'.
7. Many of Hoefnagel's drawings were published in Braun and Hogenberg, *Civitates Orbis Terrarum* (Cologne 1576–1618). On him see Eduard Chmelarz, 'Georg u. Jakob Hoefnagel', *Jahrbuch* XVII (1896) 275–90.
8. Karl Chytil, *Die Kunst in Prag zur Zeit Rudolf II.*
9. Evans, p. 264.

10. *Jahrbuch* VII (2), 'Regesten' 4660.

11. *Jahrbuch* VII (2), 'Regesten' 4656, 4648.

12. *Jahrbuch* VII (2), 'Regesten' 4627; Chytil, p. 32.

13. See J. Neuwirth, 'Rudolf II als Dürer-sammler', in *Xenia Austriaca* (Vienna 1893).

14. F. von Reber, *Kurfürst Maximilian von Baiern als Gemäldesammler* (Munich 1892).

15. Evans, p. 98.

16. The dodo was discovered in Mauritius, its only home, by the Dutch in 1598, and specimens were brought to Holland. A dodo's skull, found in Prague in 1850, probably came from Rudolf's menagerie.

17. *Euphormionis Lusinini sive Ioannis Barclaii Satyricon* (Amsterdam 1629), Part II, pp. 217–25. This part of the work was written in 1607, during Rudolf's lifetime.

18. Chytil, *op. cit.*

19. In 1806, on the death of the last descendant of count Königsmarck, the Austrian ambassador in Sweden, count Lodron-Laterano, purchased the remainder of his ancestor's spoils and presented them to the reigning Emperor. They are now in the Kunsthistorisches Museum, Vienna. Besides the busts, there were twenty-one pictures by Giulio Romano, Otto van Veen and others, the Spranger-de Vries relief of the victory at Sissegg, and Jacques Dubroeucq's bust of Mary of Hungary.

CHAPTER 4

The Archdukes and Rubens

1. Karel van Mander, *Het Schilderboek*, s.v. Scoreel.

2. *Ibid.*, s.v. Aertsen.

3. John Shearman, *Mannerism*, p. 149.

4. *The Letters of Peter Paul Rubens*, 52–53.

5. See Marcel de Maeyer, 'Rubens terug-keer uit Italië naar Antwerpen', in *Gentse Bijdragen tot de Kunstgeschiedenis* XI (1945–48).

6. Aubertus Miraeus, *De vita Alberti* (1622).

7. On this work see *Corpus Rubenianum Ludwig Burchard*, Part I.

8. de Maeyer, *Albrecht en Isabella*, p. 205.

9. *Letters*, p. 277.

10. E. Zanta, *La Renaissance du stoicisme au 16^e siècle* (Paris 1914).

11. *Letters*, pp. 277, 130, 203, 118.

12. *Letters*, pp. 185, 279, 357.

13. *Ibid.*, pp. 358–61, 392.

14. *Corpus Rubenianum Ludwig Burchard*, Part XVI, pp. 178–87, plates 92–96.

15. *Ibid.*, Part IX, p. 42, etc.

16. Roger de Piles, *Discours sur les Ouvrages des plus fameux peintres*, 'Vie de Rubens', p. 35.

17. *Letters*, p. 392.

18. *Ibid.*, p. 77.

19. *Ibid.*, p. 109.

20. Burckhardt, *Recollections of Rubens*, pp. 113–14.

21. Roger de Piles, *op. cit.*, 'Epistre'.

22. *Letters*, p. 380.

List and sources of illustrations

Numbers refer to pages

172

Index

Page numbers in italic refer to illustrations